Belair Best Practice

Teaching Art 4–7

Published by Collins under the Belair imprint

Collins is an imprint of HarperCollins*Publishers*

77 – 85 Fulham Palace Road
Hammersmith
London W6 8JB

Browse the complete Collins catalogue at
www.collinseducation.com

© HarperCollins*Publishers* Limited 2012

10 9 8 7 6 5 4 3 2 1

ISBN-13 978 0 00 745561 4

Nigel Meager asserts his moral right to be identified
as the author of this work

All rights reserved. No part of this publication may be
reproduced, stored in a retrieval system, or transmitted
in any form or by any means, electronic, mechanical,
photocopying, recording or otherwise, without the
prior written permission of the Publisher or a licence
permitting restricted copying in the United Kingdom
issued by the Copyright Licensing Agency Ltd., 90
Tottenham Court Road, London W1T 4LP.

British Library Cataloguing in Publication Data

A Catalogue record for this publication is available
from the British Library

Cover concept by Mount Deluxe
Cover design by Lodestone Publishing Limited
Internal design by SteersMcGillanEves
Photography by Nigel Meager
Edited by Alison Sage
Proofread by Gaby Frescura
Index by Eleanor Holme

Photographs:
p.33 ©sinicak/shutterstock.com,
©orxy/shutterstock.com, ©Steffen Foerster
Photography/shutterstock.com,
©Dmitriy Kuzmichev/shutterstock.com;
p.37 ©Brandon Bourdages/shutterstock.com;
p.55 and p.75 photographs taken at The Robert
and Lisa Sainsbury Collection, the University of
East Anglia by Nigel Meager in 2011.

Printed and bound by
Printing Express Limited, Hong Kong

Acknowledgements

The publication of the original edition of this book,
Teaching Art at Key Stage 1, in 1993, would not have
been possible without the support and collaboration
of teachers and children in over 24 primary schools,
mostly from the former West Glamorgan Education
Authority – in particular, Craigcefnparc, Craigfelin
and Felindre Schools. I would like to thank the then
Art Advisor in West Glamorgan, Ceri Barclay, and the
artist David Petts, both of whom were leading members
of the Visual Impact project; and Dr John Steers, the
former General Secretary of the National Society for
Education in Art and Design, who saw the potential of
this work and has offered unstinting advice and support
throughout the life of *Teaching Art at Key Stage 1*,
from its first publication through three reprints to the
publication of this new edition.

All those involved in the publication of *Teaching Art 4–7*
owe a big thank you to the teachers and children of
Dussindale Primary School, Norwich. They have my
thanks for their imagination, creativity and willingness to
try out ideas. The head teacher, Jane Worsdale, and her
deputy, Sally Coulter, enabled me to work throughout
the lower school supporting colleagues and teaching
children from 4 to 7 years old. They, and all the teachers
at Dussindale Primary School, were open-minded and
encouraging at every stage of this project.

Particular thanks to Lee Newman, Alison Sage and
Aimée Walker from HarperCollins for all their support
and their work in editing and refining the text and
images. Thanks to Jon Ashford and Richard McGillan
of SteersMcGillanEves for the design.

Several excellent photographs were taken by
my colleagues at Dussindale Primary School,
Susanna Manrique and Sarah Spears.

Nigel Meager

MIX
Paper from
responsible sources
FSC C007454

FSC™ is a non-profit international organisation established to promote the
responsible management of the world's forests. Products carrying the FSC
label are independently certified to assure consumers that they come from
forests that are managed to meet the social, economic and ecological needs
of present and future generations, and other controlled sources.

Find out more about HarperCollins and the environment at
www.harpercollins.co.uk/green

Belair Best Practice
Teaching Art 4–7

By Nigel Meager

Teaching Art 4–7

Contents

The background to *Teaching Art 4–7*

Teaching Art 4–7 is, in effect, the second edition of *Teaching Art at Key Stage 1* (the National Society for Education in Art and Design (NSEAD), the UK's professional association for teachers and educators concerned with art and design education), published in collaboration with Visual Impact Publications, 1993. *Teaching Art at Key Stage 1* was recommended on primary teacher training courses, and many primary schools had a copy in the staffroom. This new edition closely follows the pattern of the original, but it has been brought up to date, in particular through the use of new photographs of children working on the activities in a primary school.

The original *Teaching Art at Key Stage 1* was born out of forward-thinking policy in the former West Glamorgan Education Authority. This local authority had been pioneering projects that placed artists in schools and in 1980, the Art Advisor in West Glamorgan, Ceri Barclay, helped to establish an education service at the Glynn Vivian Art Gallery. (The gallery was managed by Swansea City Council.) This service went on to organise many projects where artists worked with children, either in the gallery or in schools, and Arts Council Wales and the regional arts association, West Wales Arts, helped with the funding. The principle of the value of a partnership between professionals working in the visual arts and those working in education was firmly established.

It was within this context that in 1988 a group of artists and head teachers secured support from the Calouste Gulbenkian Foundation, West Glamorgan Education Authority and Arts Council Wales. This new project was called Visual Impact. The aim was for artists to work with primary school children in partnership with class teachers. Artists would be classroom-based visual advisors. They would not concentrate on their own work, but would offer primary school teachers the wider benefits of their training and professional expertise in the visual world. Teachers would learn about art from the artists and artists would learn from teachers about what was practical in the classroom. Right from the start, it was hoped that new or improved ways of teaching art to young children would develop. Two artists, Nigel Meager and David Petts, remained close to the Visual Impact Project which ran until 1992. Nigel had an MA in painting from Newcastle University and was at that time based in Swansea and working as a professional artist.

Talking clearly and straightforwardly about art and design was at the heart of Visual Impact. So a crucial test for including an idea in the original publication was whether the approach could be described

and then taken up by a teacher with little or no background in art. The motto for *Teaching Art at Key Stage 1* was: 'Teachers don't need to be good at art to teach it well'. Art and design can be taught using the same skills that good teachers practise every day and qualities needed for good teaching are similar to those needed to create art.

The Visual Impact project was based in three schools in West Glamorgan: Craigcefnparc, Craigfelen and Felindre Primary Schools. However, ideas from the project have since been tried in numerous different education authorities and many thousands of schools, and with support from the Calouste Gulbenkian Foundation, were published in 1993 as *Teaching Art at Key Stage 1*.

The story of this new edition began in 2010 when Collins Education acquired the Belair imprint and decided to launch a new series under the Belair label called *Best Practice*. They approached NSEAD about new editions of *Teaching Art at Key Stage 1* and *Teaching Art at Key Stage 2*.

Nigel Meager had written *Teaching Art at Key Stage 1* (1993) and *Teaching Art at Key Stage 2* (1995), followed by *Creativity and Culture – Art Projects for Primary Schools* (2005) in association with NSEAD. He worked extensively all over the UK, producing professional development courses for primary school teachers, and in the classroom as an art education consultant, as well as lecturing at teacher training colleges. However, Nigel had never trained as a classroom teacher. Nigel returned to the United Kingdom in 2009 after working in Costa Rica and Panama, and decided to enrol on a postgraduate course at the University of East Anglia to train as a primary school teacher. He felt that without this, it would be difficult to extend his considerable art education experience. Subsequently, in 2010/2011, he taught a class of 30 six to eight year olds at Dussindale Primary School in Norwich and this is where the projects illustrated in this book took place.

Clear communication is one of the important principles which underpin this work, together with well-written text, which concentrates on the voice of the teacher talking with children. As a visual artist, Nigel realised that photographs could communicate a great deal to teachers and student teachers. From his perspective as a class teacher, Nigel considered how best to photograph children in the classroom. Could photographs capture something of the learning taking place, from a child's point of view? Could photographs help build an intuitive understanding of this way of working? The design of the book has been carefully developed to harmonise the photography and text, providing clarity to the narrative whilst retaining the visual impact of Nigel's photographs. In this way, *Teaching Art 4–7* is itself a marriage of the same qualities of teaching, learning and visual sensibility which should underpin the best of art and design education practice.

NSEAD has a comprehensive website, featuring useful resources for teaching art: www.nsead.org/primary. It includes links to articles about best practice in teaching art and design to young children. NSEAD believes that teaching creatively and teaching for creativity should be at the forefront of current thinking in primary education. Use the links on the website to find out what that means for you. To describe how creativity can work in the classroom context, it is essential to use images, as well as words. It is for this reason that the author has included many photographs which he took while teaching the sessions outlined in the text. Please enjoy the images and allow them to help you enhance your intuitive understanding of art and design in teaching and learning.

Dr John Steers, General Secretary,
National Society for Education in Art and Design

Introduction

Teaching Art 4–7 in the classroom

Schools and teaching art

Art and design in school is a broad church from whichever cultural or educational perspective is adopted. A curriculum may focus on developing skills or on free and personal expression. Art and design could be part of cross-curricular teaching, in which case, art as a manifestation of cultural expression may predominate. Perhaps a curriculum is led by ideas about design and is therefore more closely allied to technology. A broad and balanced art and design curriculum may involve all of these aspects in some form or other. The ideas expressed in *Teaching Art 4–7* suggest that teaching and learning in art and design should:

• stimulate creativity and imagination
• provide visual, tactile and sensory experiences
• offer unique ways of responding to the world
• be a form of communication about what is seen, felt or thought
• help children to understand and use materials and processes
• encourage the exploration of the visual elements of shape, line, pattern, colour, form, space, tone and texture
• offer insights into how artists, craftspeople and designers work
• offer a cultural context for art and design
• provide an opportunity to understand and enjoy the arts.

Art-based activities are also a powerful tool in supporting creative development, communication, knowledge and understanding of the world for children in the early years, through planned and purposeful play. (See *Teaching Primary Art and Design*, Learning Matters, 2009)

Developing visual awareness and the visual language of art and design

Vision provides so much of the raw material for learning. What we learn is bound up with what we see. More than this, being able to see the world delights us and informs us, it moves us and enriches our lives. The visual world and our perception of it are fundamental to how we think, act and feel. This is central to learning.

It is therefore surprising that more classroom time is not devoted to developing a visually aware child. Children could be helped to understand how they see the world, just as they are helped to learn how to read and write. Developing visual awareness will empower young children, as bit by bit, the richness of the visual world as well as the huge variety of possible visual responses are opened up.

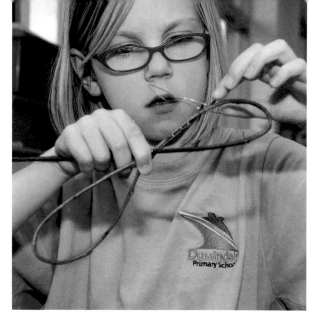
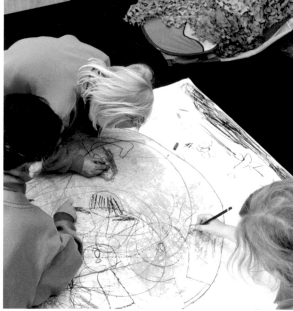

One way of using this book is as a resource of practical classroom strategies for the simple and effective development of children's visual awareness. The visually perceptive child has so much more to talk about, write about, record, contrast and compare. There is just so much more to see and so much more to be excited about. Developing children's visual awareness, helping them to understand how they see, empowers them to learn and express themselves. It enriches the quality of being alive.

When we focus on how we see differences in the qualities which make up the visual world, we can choose to perceive the world in terms of: shape, pattern, colour, form, space, tone, texture and line. These visual, tactile and spatial qualities (they have also been called formal elements, visual elements or visual concepts) provide the chapter headings for the projects in this book. It is as if they constitute a visual language of art and design. The aim is to break down the development of visual awareness into an easy-to-manage and practical structure for the primary school classroom. As children become familiar with the concepts and their practical manifestations, they begin to use them more coherently in their own work.

Thinking visually helps children to make art, craft and design. These visual qualities can be used to focus children on the appearance of an object, a landscape or a person. This means they will know what to look for when they are drawing. Children will also recognise these same qualities in an art, design or craft object. Artists, craft workers and designers manipulate these visual qualities as they work. Children will learn to manipulate them in similar ways as they experiment with new materials and techniques.

Ideas, feelings, creativity and imagination

If young children are to have more choice about the ways they express themselves, they will need to be systematically introduced to a wide range of possible ways of working. The best way to achieve this is to let children explore, experiment and investigate ways of working for themselves, within an appropriate framework. Children need clear, practical structures within which to work and their teachers need a framework within which to teach. The visual elements – together with a description of a number of different art and design skills and processes – provide teachers with a possible framework which they can use to plan a wide and challenging variety of art-based activities to foster creativity and nurture imagination.

When children can manipulate visual qualities, they are more empowered to express ideas and feelings. In each of these examples, the visual elements become a conduit for expression: the tone of the light of a dark and brooding sky; a monster with a jagged form; the eerie space of an empty beach in winter; a bright and cheerful pattern made up from higgledy-piggledy shapes; the texture of an animal with soft, cuddly fur; the colour of a red and angry face; the shape of a body curled up to hide; the extraordinary lines in a jumble of tangled vines.

This book shows that it is possible for teachers to help children develop their visual awareness as soon as they start school. This work builds a visual language for both an increasingly sophisticated exploration of the world and the expression of ideas and feelings. All children have the right to be able to use art to communicate. Art is not just for artists.

Planning for art lessons

There are numerous ways of planning for teaching and learning. Different schools in different regions of different countries will have their own planning structures. Sometimes these are linked to national policy, sometimes to the requirements of local school boards or education authorities; sometimes a particular planning policy is unique and forms part of the underlying culture of teaching in an individual school.

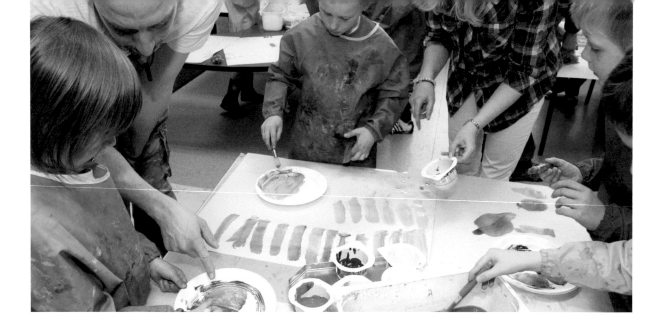

However, good planning for art and design will always be grounded in objectives which are achievable within the context of the child, the teacher, the space and resources available. So, what were the principles underlying the activities planned in this book?

Talking with children is fundamental: about what they see; what they might explore; what they can discover in art and design images and objects that their teacher points out to them; what they have found after experimenting and exploring with materials and ideas; what difficulties they encountered; what pleased them; and what they thought was significant in their own and their classmates' work. There is a direct correlation between the quality of talk and the quality of children's work.

Allowing children to explore and experiment is essential. In this way, they can play with materials, processes and ideas; they can gain experience and get an intuitive feeling for and feel more confident about the characteristics of what they are using and thinking about. In *Teaching Art 4–7*, experimentation always precedes work that is focused on producing a more finished outcome. It is usually abstract in nature, so that at the start, children are experiencing the qualities of materials, processes and ideas for their own sake, rather than for what they represent. In many ways, experimentation equates to warm-up and starter activities used before lessons in maths and literacy.

Careful teaching of a systematic way to learn a skill, or practise a process, gives children confidence to express their ideas in art and design. This may take the form of showing children how to organise their work area (having a dirty and clean side of the table when printing, for example). It may be important advice about using equipment (for example, washing and drying a brush before taking a new colour from the paint pot). It may be advice about what to watch out for (start by drawing a shape in the middle of the paper rather than at the edge, so that a portrait drawing fits more easily onto the space of the paper).

Different artists and designers develop their own, unique ways of working with the tools, materials and equipment appropriate to their genre, so advice about a particular skill (colour mixing, for example) is far from being prescriptive. What is important, though, is that children are able to focus on the matter at hand. It would be hopeless to ask children to explore the wonders of mixing a limitless array of colour, if they were unable to control the paint they had been asked to use. A free-for-all serves no purpose at all.

Evaluating and assessing art

Taking time to allow children to show what they have produced and to see what other children have been doing is vital to establishing art and design as an essential way of communicating ideas and feelings. This builds an awareness of art and design as cultural expression. Meaning is, in part, dependent on the point of view of the observer and consumer. Children's art will have a different meaning for the artist who made it, the teacher who is assessing it, and the parent who delights in it because it was made by their child.

Evaluating, appraising and assessing children's learning in art and design is seldom straightforward. Taste, cultural perspective, even what the observer thinks art is, or should be, all come into play. Judgements are difficult and can vary widely depending on who is judging and on which criteria, if any, they are using. Planning for assessment will need to fit whatever planning structure is appropriate in your school setting. As the children work, watch how they engage, see what they do, listen to what they say and take an interest in what they produce. Use talk to introduce and extend children's technical and critical vocabulary. Please do not let rigid assessment dominate your teaching, so that you dictate how an art experience unfolds for a child. Always keep in mind that art is a form of communication and is often charged with meaning for whoever made it, even if that person is only five.

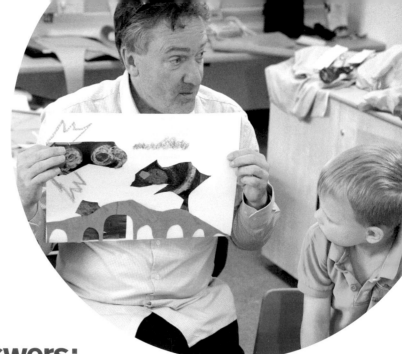

Questions and answers: how to get the most out of this book

Does the book describe a complete system?

No, not at all. This is only a taste of what is possible. It is only one way of thinking about teaching and learning in art and design, although I firmly believe that a focus on visual elements is useful, as it helps mitigate against too much concern with end products. There is a great deal of art and craft work in schools which is very adult-led, where children have few decisions to make and where outcomes are very predictable. At Dussindale Primary School, children are openly encouraged to be risk takers, to question, to experiment and explore. These qualities help to promote inventiveness and creativity. Such children become unafraid of trying out new ways of working and are more adept at thinking outside the box. The activities in this book are set in that context, too. Many are starting points for experimenting and exploring. In that spirit, I hope that the text and photographs will prompt teachers to think up other ways of developing visual awareness and building confidence in the many expressions of art, craft and design.

What is the significance of the chapter headings?

The book is divided into eight practical sections. These reflect the emphasis on developing visual awareness and the language of art, craft and design, which is why chapter headings correspond to the visual qualities described on page 8, shape, line, pattern, colour, form, space, tone and texture. These headings have been used within art education for many years and are familiar to art specialists as the 'formal elements'. This book applies these visual qualities (or formal elements) to the teaching of children from four years old. Developing visual awareness and a visual language, with all the accompanying benefits for learning as a whole, can start as soon as a child enters school.

Can I just dip into the book?

This book is not intended to be read through in one sitting. Dip in to the pages to get a feel for the way the ideas might work in the classroom. The photographs play an important role here. Look at the images carefully to gain a more intuitive insight into what is happening. All the images were taken as I taught the various classes. You can also use the index to hunt out particular themes or processes. Once you have a starting point, it would then be useful to read through a sequence of sub-sections to see how one activity can build on another.

Is there a progression from chapter to chapter?

There is no intention to describe a progression from chapter to chapter. Conversely it would be a mistake to try and implement all the ideas at once.

So where should I start?

If you teach very young children or if you have never worked in this way before, you could begin with the early sessions of the chapters on shape, line, pattern and colour, in that order. Of course, other combinations could also work well. For example, a school could decide to concentrate on colour and get that working for each year group before moving on to another section.

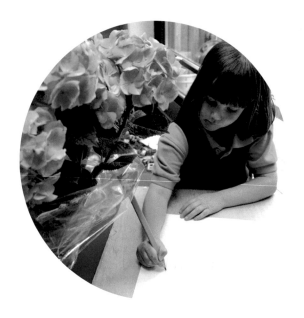
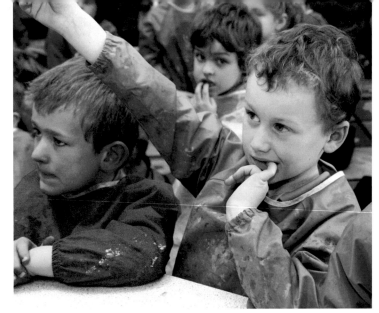

Is there a progression from activity to activity through each chapter?

There is a progression implied in the way the activities unfold through each chapter. This progression is not cast in stone. However, if you are working with older, more advanced children, it might be tempting to skimp on the talking and investigative work and get straight on with making something. Please do not do this. To avoid repetition, modify the language and initial stimulus to accommodate the needs of more advanced pupils.

What are the session headings for and do I need to work through every session in each chapter?

The session headings are an indication of how you might divide up the work into manageable chunks of activity. This is, of course, variable depending on the age of the children, the characteristics of your class, the space of the classroom and how much adult help is available. So they are only a loose guide. But I hope the principle of thinking in terms of sessions might help you plan lessons. The sessions in each chapter do build upon each other, but there is no need to stick to the order in a rigid way. Planning a sequence of activities that builds depth and quality into the art is a recommendation implicit throughout the pages of this book. It is important to include a number of different explorative and discursive activities that lead up to making art. Why not design your own series of lessons to suit the needs of your children, but with the activities described in this book as a prompt, or starting point?

Why is the text written in such a particular style?

There are three main voices running through the text. There is the voice of the book, setting the scene, giving hints and advice about the practical processes and commenting on what might happen. For example:

We are going to teach children a process that will help them to glue without getting in too much of a mess. When they have had some practice they will be able to make some imaginative collages.

Secondly, there is the voice of the teacher talking to the children. The aim is to phrase the questions and comments teachers might make in a way that gives an atmosphere of the classroom, as well as giving clues about how to start the activities. For example:

I am going to tear this paper to make an edge. Watch. What does the edge look like? How did I make the edge? Could anyone think of a way of tearing a really rough looking edge? Come and show everybody your idea.

Thirdly, there are guidelines about the materials and equipment that will be needed. For example:

You will need: A3 paper; drawing media, including soft pencils, black wax crayons or handwriting pens.

These You will need boxes appear only when the materials you require are significantly different to those listed in the previous activities.

Occasionally there are comments from children that illustrate the way they talk about investigative work. For example:

"Looks like scales on a snake's skin...like a piece of toast"

Do I need special materials or equipment?

Suggestions for the materials and equipment you need are listed with each project and also at the end of the book. This will help you with planning. There are also suggestions of where to look for more ideas. Throughout the text you will find references

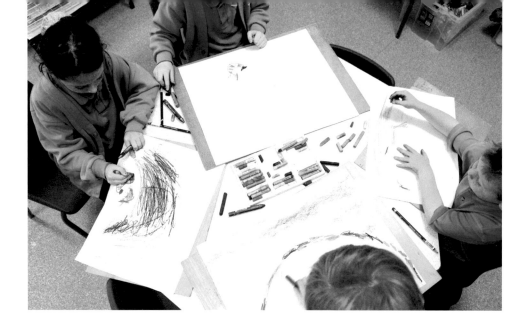

to drawing boards. These boards are made from thin plywood or MDF board. You will need enough for the largest class in the school; they can then be shared from class to class. These boards are lightweight and allow children to work outdoors, in the hall and on the floor of the classroom or corridor. They are invaluable for creating extra space and allowing children to enjoy an individual working area. Dussindale Primary School also cut bigger sheets of hardboard to cover two rectangular classroom tables arranged as a square. These hardboard sheets protect the tables, and give a non-slip base for children to work on. They are light and easy to move and save time when clearing up. They can of course be used again and again.

Where can I find appropriate examples of art, craft and design to use when talking about art with the children?

There are many ways of providing the necessary resources. The quickest is to search the internet for relevant images. Unfortunately, in UK schools, classrooms seldom have good blackout facilities and the power of whiteboard projectors is not sufficient to project quality images. The colour is often washed out and detail difficult to see. If a blackout is impossible, then perhaps it is best to use art posters. Another tactic is to print a few smaller versions of the image so that small groups of children can look at them carefully. You can also collect reproductions and photographs from colour supplements and magazines; collect postcards from art galleries; write to galleries and ask to be put on their mailing list for posters and invitation cards; visit a gallery with the class; or organise a visit by an artist to the school. Also, bear in mind that design covers a very broad area indeed, and you could include examples such as landscaped gardens, hairstyles, motorway bridges, architecture, book covers, knitted fabrics and so on.

One way of organising material you want to show the children would be to identify the visual quality shown in the example you are considering. You could organise boxes or digital files containing good examples of art that exemplifies shape, pattern, colour, form, space, tone, texture or line. An alternative is to organise your collected examples by theme or topic.

Do the projects fulfil the requirements of a formal curriculum in art?

The good art practice described here should naturally and effortlessly meet the demands of any formal curriculum.

Are there examples of cross-curricular opportunities within the text?

Most of the work is cross-curricular in one way or another. The use and development of language is a recurring feature throughout the text. Some teachers may feel that the activities described in the book are worth the investment of time simply for the benefits to language development. Here are some more ideas about cross-curricular opportunities:

The work in the chapters on shape and form can link strongly with maths, as can the work in the chapter on space, which will help children learn terms that describe position. The early part of the pattern chapter also teaches children about repeating patterns.

The chapter on texture links strongly with an exploration of materials in science. Link the chapters on colour and tone with science. Children can learn about colour, light, shadows and so on.

Look at the chapter on line for links with music and movement.

All the advice on drawing, which occurs throughout, will help children record their experiences. This supports investigations of the natural and made environments.

Use the index to identify examples of how the activities in the book link with specific themes and topics.

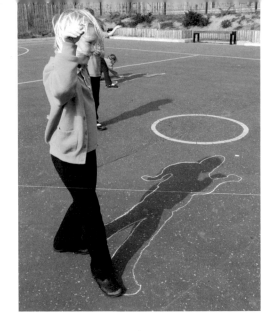
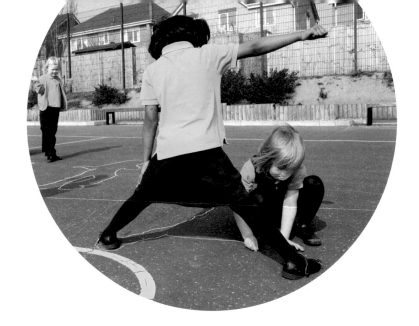

What is included in the index?

The index lists art, craft and design processes, examples of a basic subject vocabulary, and a general listing of terms used in the text. At the end of the book there is also a list of materials and equipment referred to at the end of the practical activities and suggestions of where to go next for ideas.

At what age could children be expected to try each activity?

You will notice that there are no recommendations as to whether a session is appropriate for a particular age group. If older children have never worked in this way before, then all the sessions are appropriate, providing the language of delivery is modified. Although the content is aimed at children from four to seven years of age, eleven or twelve year olds new to this way of working should move very quickly through the sessions. There should be a correspondingly rapid improvement in their investigative and making abilities, as they will quickly understand more about the visual qualities implied. In contrast, I am constantly surprised at what the youngest children can achieve, if art activities are broken down into small, easy-to-understand units of work, as the text suggests.

Are the ideas really suitable for four year olds?

Much of the text, particularly towards the start of each chapter, is written with these children in mind, and they also feature frequently in the photographs. As each chapter progresses, some of the sessions tend to become more complex, but I am constantly surprised by how much young children are able to do, especially towards the end of their first school year.

What about older children?

Much of the content of this book provides a starting point for older children as well. I hope teachers of children from seven to eleven years old will also find the book very useful. When this foundation for visual awareness and the visual language of art and design is in place, children have the means to express ideas and feelings. In other words, as children progress through school and build on the approach shown in this book they should become increasingly open to their creative and expressive potential. They will be empowered to tackle a wide range of issues with a depth and breadth of feeling. The ideas in this book for the youngest children are complemented and extended for older children in *Teaching Art 7–11* (Collins Education, 2012).

"My pencil, the computer, Mr Meager's bag…I looked outside and saw shapes…clouds have shapes!"

Finding out about outlines and drawing shapes

Session 1

Talking about shapes

Look around the room. Can you see any shapes? Let's make a list of the shapes you can see. Who can see a shape that is bigger than I am? Who can see a shape that is smaller than your hand?

Children will immediately think of the shapes they have learnt in maths. The first step is to link the shapes they know through maths with the shapes of different objects and images they can see in the room. If they have not yet learnt about squares, rectangles and so on, start with the next activity, drawing around objects and shapes to make outlines.

Drawing around shapes and finding out about outlines

Look. Here is a shape from the shape tray. I can draw a line around this shape. This is an outline. I can find the outline of all sorts of things. What shall I try next? A spoon? A key? Let's try a few more. These outlines make shapes. Look at the shapes we have drawn. What can you recognise? We can recognise an object by the shape it has. Now you can draw around more things to make some shapes of your own.

After you have made a few outline shapes with the children, ask them to collect some more on their own. Provide a collection of interesting objects or the children could hunt around the classroom and discover shapes for themselves. Afterwards, they could try and guess the objects that go with the outlines that other children have collected.

You will need: a large sheet of paper on an easel or drawing board to demonstrate drawing around shapes; A3 paper and drawing boards or sketchbooks to collect outlines; soft pencils, small black wax crayons, felt-tips or handwriting pens for making good, clear outlines.

Session 2

Finding shapes by looking

The children have been drawing around objects to make shapes. The next sequence of activities should help them collect different outlines by looking and drawing.

I want to collect the shape of the large window in the classroom. What are the problems? Can I put the window on my paper and draw around it? Why not?

Look. If I close one eye and point at the window, I can trace around the outside of the frame to draw a shape in the air. Let's all practise.

Here is a black wax crayon. I can look at the window and instead of tracing around the frame with my finger in the air, I can draw the shape with the crayon on the paper. This time I am using a crayon, not my finger and I am drawing on the paper, not in the air. I have to look carefully at the shape of the window.

Look at the shape I have drawn. Now you can find the shape of anything you want to. Just look carefully, trace around the shape in the air with your finger, and then draw the outline on the paper. Let's try and draw the shape of this electric fan together. Tell me some of the other things in the room which have outline shapes.

Collecting shapes by looking and drawing

Now you can hunt around the classroom and collect different outlines by looking and drawing. See how many you can collect. Don't draw too much detail inside your shape. It's the outline that's important.

Above: tracing shapes in the air

Right: drawing in the classroom focusing on shape

Children could collect shapes of things much bigger than they are, or they could even look out of the window and collect shapes of things outside. The children should look carefully, but they shouldn't worry about making mistakes. The important thing is that they are looking at and drawing shapes. If they make attractive drawings, that is a bonus. Soon they won't need to trace the shapes with their fingers; they will just look and draw.

Talking about the shapes you have collected

Who found an outline shape in the room of something very large or something very small? Who found an outline shape with straight lines or with curves? Who found an outline shape with bumps or points? Did anyone find an unusual shape? How would you describe it?

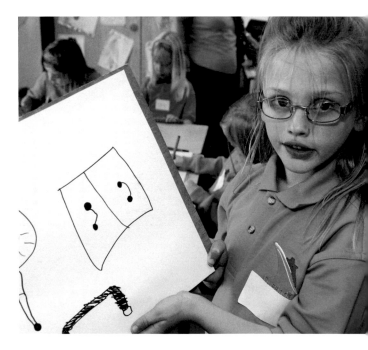

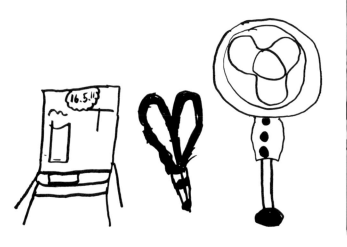

Session 3

Making collections of different categories of shapes by sorting

On one piece of paper, draw all the shapes you have found of things that are bigger than you are. On another sheet, draw all the shapes you have found with points.

There are many other ways of categorising shapes. The children could work on large sheets of paper and make these collections together.

Inventing large shapes

First, draw a large shape with the children so they can see the idea. Ask the children to suggest different kinds of line that could be used to make up an outline, for example: a curved line, a straight line, a line with bumps, a line with sharp points and turns. Look at page 26 for more ideas about working with line. Children could then work together and draw some large shapes of their own.

You have made some large shapes. What do they remind you of? What can you see in your shapes?

"Dots...stars...circles...a bird with a very big mouth...a pelican... a snowman's nose...teeth..."

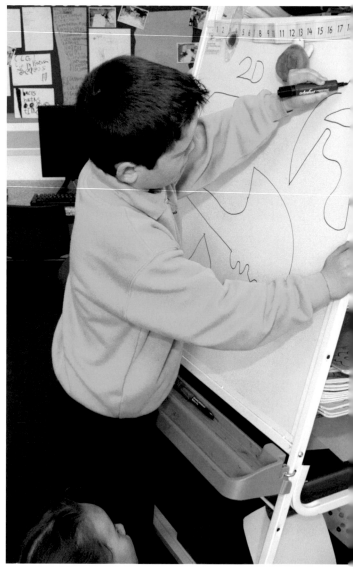

Top left: a selection of shapes from the classroom

Top right: making your own shape collection

Above: using lines to make large shapes

Figures and portraits

Session 4

What shapes can your body make?

When we are doing different things our bodies make different shapes. Have you any ideas about what you could pretend to do? How about curling up and pretending to sleep? Stretch out on tiptoe to reach for something high. Dig a sandcastle. Catch a beach ball. Push against a table. Play tug-of-war with a friend. Look very sad and lonely.

You could work from a theme such as 'What do you do at the seaside?' or 'What do you do in the playground?' or 'Different feelings'. The children will have more ideas than many adults. It is great fun asking them what they are going to do, freezing them in mid-action and talking with the class about the shape the body has made. You could also go outdoors to make shadow shapes, see page 68.

Collecting body shapes

This large piece of paper on the floor is big enough for you to draw the outline of your friend pretending to do something. Draw around the shape of your friend slowly and carefully. Let's collect a body shape from everyone. Now we can talk about the body shapes. Which ones are similar? Which ones look nearly the same? Which look small? Which are long and thin?

You will need: water-based felt-tip pens so the shapes show up clearly; paper from a wide roll (or you could join smaller sheets together).

Drawing body shapes by looking

Ask for a volunteer to make a body shape for the others to draw. The children should guess what he or she is pretending to do. Ask them to look very carefully. The children could use their fingers to trace the body shape in the air first (see page 17). They can now draw the body shape on their paper. After they have drawn the shape, children could add in anything else from memory to go with the figure. For example, if the model was digging a sandcastle, some children might want to add a bucket and spade, etc. Repeat this process three more times to fill the paper. The children could then choose one of their figure drawings and make an imaginative painting. Perhaps their painting could show a number of people doing different things.

You will need: large pieces of white paper; drawing boards, drawing media such as soft pencils, handwriting pens or black wax crayons. You could use colour to extend the imaginative potential of the drawings.

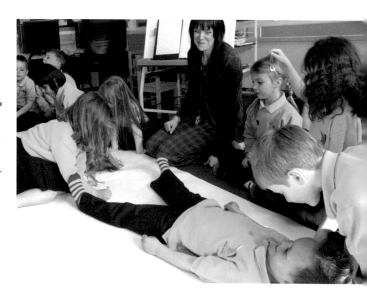

Above: drawing by looking carefully

Right: drawing around your shape on a large roll of paper

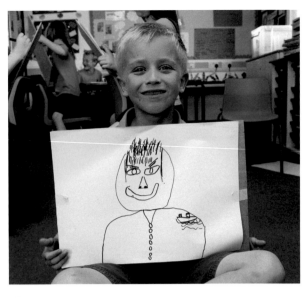

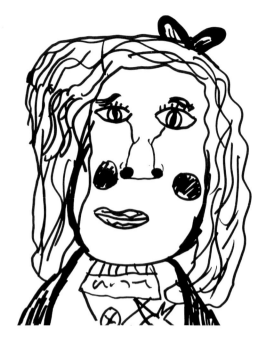

Session 5

Drawing heads and faces

Look ahead to page 22. The process described in detail there in relation to buildings also works well for drawing heads and faces. Ask the children to start by drawing the eyes, nose and mouth.

Children may worry about mistakes. They often ask for rubbers. Some children are so concerned about making an accurate drawing – a correct drawing – that they have no confidence in their work and are always rubbing out or asking to start again. Encourage them to keep going. Everyone makes mistakes! Or ask all the children to use a handwriting pen or black wax crayon, so that no one can rub out.

You will need: drawing boards; A3 paper; clips or masking tape. If you are working outside, use masking tape on the corners if it is at all windy. Use any drawing medium that will make strong, dark lines.

Above and below: drawing by starting with the eyes, nose and mouth

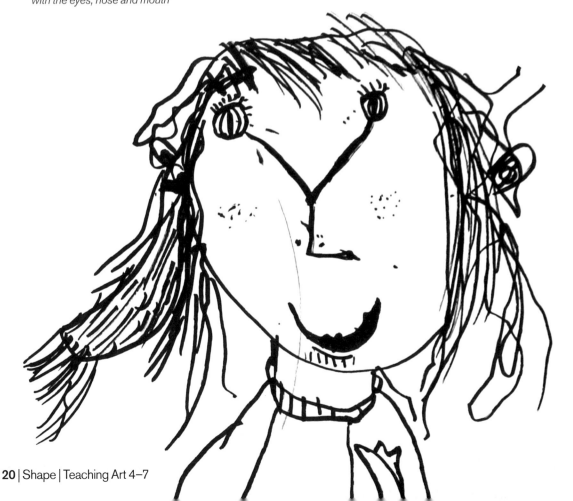

Drawing buildings

Session 6

Looking for shapes inside shapes

The sequence we are describing has buildings as its theme. The first activity is a good warm-up exercise before making observational drawings. It will help to refocus children on shape, especially if it has been some time since they were last thinking in that way. Look back at page 17 for ideas about helping children to look at and draw shapes. When they have finished drawing, talk about what the children have found. This session will also work well outside.

Who can tell us some of the things in the classroom that have large outside shapes and some smaller shapes inside them? Here are some ideas: the whiteboard, a large window, the door, the cover of a book. What else can you think of?

Hunt around the classroom and collect shapes of large things by looking and drawing. Can you see any smaller shapes inside the large ones? Draw them in, too.

Talking about a building

Look at the front of this building. What can you see? Let's make a list of all the things you mention. What about all the different shapes? Let's talk about all the different parts of the building that have a shape. What are the shapes like?

You could talk about any building in this way. Maybe there is a good, large reproduction available of architecture the children would not usually see – a historical building, perhaps. But why not start with the school, or the different houses, shops, factories and places of worship close by?

You could ask children to collect the shapes of a building, or use the idea of collecting shapes inside shapes, as on page 22. You could also talk about the colour and the texture of the building.

What is the building for? What happens inside the building? How does the building make you feel? Is it different from where you live? Why? Do you like the way the building looks? Or do you dislike it? What do you like or dislike about it? Why?

You will need: A3 or A4 paper and clipboards or sketchbooks; any drawing media that will make strong dark lines such as soft drawing pencils, handwriting pens, etc.

Above: drawing the school
Left: drawing outside with drawing boards

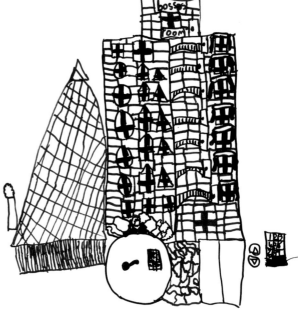

Session 7

Drawing a building

You can use a version of this to help children draw any building, although here we are going to focus on the school. This is observational drawing – a study – with a focus on shape.

We are going to look at the front of the school. First of all, let's trace around the outline shape of the school in the air with our fingers. We need to be far enough away to see. What would it look like if we were too close? Think carefully about the shape the school makes. Is it tall and fat, or long and thin? Are there any points? Are there any diagonal lines? Think about how the school is going to fit on your paper; but don't draw the outline shape of the whole school. First, look carefully for all the shapes you can see inside the shape of the school. Choose a smaller shape from the school that you would like to put in the middle of your paper. It could be a door or a window. When you have drawn that shape, start adding in the shapes around it. Your drawing will spread from the centre. Draw in as many of the inside shapes as you can see. Can you put the shapes in the right place? You will need to work slowly and look carefully. Don't worry if you make a mistake, just keep going. When you think the time is right, draw the outline of the whole school.

You could ask children to draw the outline first, putting smaller shapes in as they work on their drawing. But if children start with a large outline, they very often have problems with scale and proportion. If they start from the centre and work outwards, they have more success. This method works for portraits, buildings, and it could also be adapted for drawing: landscapes, gardens, collections of fruit and vegetables, objects from the current topic, machines, etc.

Architecture and drawing buildings from observation

If you have guided children through the activities in this chapter, they will be well primed to have a go at architectural drawing. The illustrations are examples of different activities. Some children chose to work from a selection of images of contemporary buildings in London. These were photocopied and enlarged where necessary. Children traced the shapes and then went on to make their own versions with felt-tip pens and paint. In another project, children were asked to create imaginary buildings. There was a lot of talk about what kinds of buildings they were going to design. Some children were inevitably influenced by the images of buildings in London. The drawing top right shows a block where the inhabitants live on one side and cross a bridge to work on the other side of their floor. Note the 'boss's room' overseeing the whole enterprise!

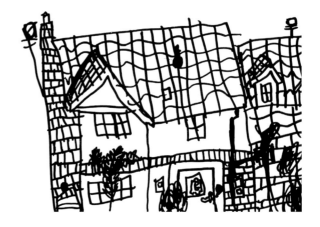

Top left: this drawing is made with felt-tip pen and paint after first tracing the image of a building from a photograph

Top right: architectural drawing of an imaginary building

Above: drawing of a building

Collage with shape

Session 8

Cutting and tearing experiments

I am going to tear this paper to make an edge. What does the edge of the paper look like? How did I tear the paper? Could anyone find a way of tearing a really rough edge? Come and show us. What other sorts of edges could you make? Here is one with a lot of sharp points. Here is one that is wavy. Each of you can experiment with scissors and with your hands. See how many different edges you can make.

Ask the children to explore different ways of cutting and tearing paper. Use black paper for the tearing and cutting. Ask the children to lay out their edges on white paper so that they can see clearly what they have made.

The gluing process

It is so much easier for children if they have a clearly defined working space. There should be a line down the middle of each area to mark a boundary. There will be a clean side for the collage and a side for gluing. If children are working on tables that wipe clean, use a water-based marker pen to delineate the working areas. We used masking tape on large sheets of hardboard cut to fit the size of the tables in the classroom.

Here is an area for you to work in. There is a line down the middle. One side is where you will do all the gluing. The other side is where you will have your work. The glue and the newspaper and the glue spreader and the damp rag must always stay on the same side of the board, the gluing side.

Take a sheet of newspaper and lay it on the gluing side of your area.

Here is a piece of paper with one of the edges that you made. Lay it on the newspaper. Look. What happens if I put too much glue on? What happens if I put too little glue on? What happens if I only put the glue in the middle of the paper shape? Use the spreader to put the glue around the edges of your shape. You will need to hold it steady. Where would be a good place to put your fingers to hold the paper? In the centre! Now, on the other side of your work area, stick your shape down onto a piece of white paper to start your collage. Wipe your hands. Take a clean sheet of newspaper and lay it over the first, sticky sheet. Repeat the process, gluing and sticking down torn shapes and edges onto your collage.

REMEMBER: always put a fresh sheet of newspaper on your work areas every time you glue. Wipe your hands. Keep the glue, the spreader and the newspaper on the gluing side.

The children could cut and tear more paper in different colours to collage on top of their first shapes. Try any combination of colours for colourful experiments. Think up another way they could practice gluing.

You will need: see page 24

Above: cutting and tearing
Left: collage

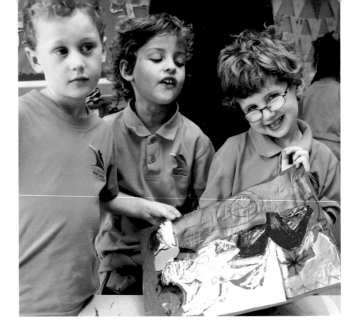

Session 9

Imaginative collages

Ask the children to think up different ways to colour A4 or A3 size sheets of sugar and scrap paper. Use a wide range of colours. They could use soft pastels, wax crayons, anything in fact! Each child will need to colour several sheets of paper. If you use soft pastels, you will need to fix the colours with firm-hold hairspray before the children make the collage.

Don't let the children draw with pencils first. Ask them to start tearing and something will come up. Demonstrate what you mean. Of course, once they start, children will create all sorts of shapes that will inevitably remind them of something recognisable.

They can now glue the shapes down on a clean sheet of paper. The children could collage more ideas, or they could finish the pictures with crayons or pastels. Use the finished work to generate stories. Children will talk about what is happening in their collage.

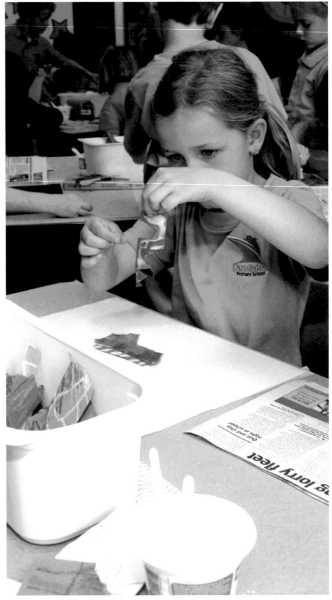

You will need: an area to work in, marked out with a clean side and dirty side; paper for cutting and tearing; paper to glue the collage onto; a variety of colouring media such as soft pastels and wax crayons; firm-hold hairspray to fix soft pastels; PVA glue for gluing paper; plenty of newspaper cut into quarter sheets (old magazines could also be used and each child would then turn a page of the magazine every time they glue); a glue spreader; scissors; a damp sponge or rag for wiping sticky hands.

Right: children applying glue on top of a clean sheet of newspaper on the dirty side of the work space, and sticking each piece of paper onto their collage on the clean side of the work space

Top right and opposite: talking together about the finished collage

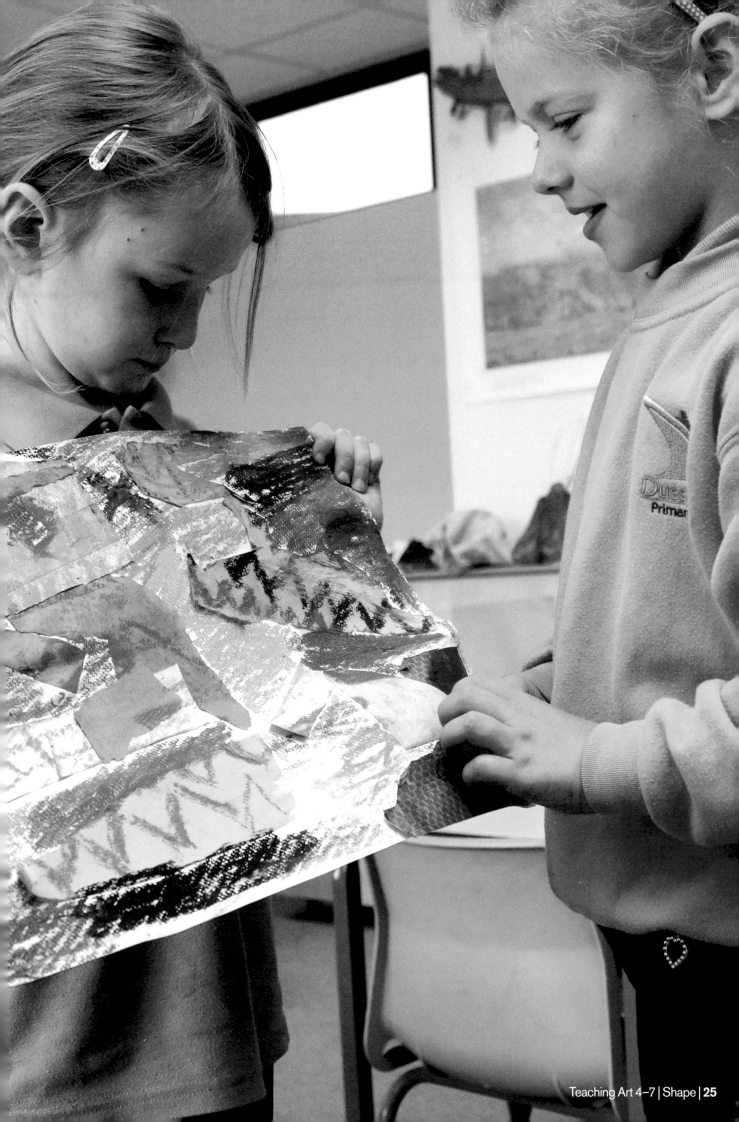

"Zigzag, fast, like a snail, bumpy, from side to side, really long, like a tangle, hairy lines…"

Exploring line

Session 1

Experimenting with line

I can make a line with a curve. What lines can you make? Who can make a new kind of line on this paper? Try and think of a different way to make a line.

Begin by showing the children how easy it is to draw a line. Talk about all the possibilities: lines can be wavy, zigzag, straight, curling, etc. The children are now going to make their own lines.

Let's experiment. You are all going to make lots of different lines. I'll call out a few to start with. Make a long bumpy line. Make a short spiky line. Now experiment and make some lines of your own. You can put your lines anywhere on the paper.

There are lots of different ways of talking about these experiments. You could hold up one child's paper or ask the children to compare two experiments. Alternatively, the children can identify particular lines and talk about what they are like. If you are in the playground, the children will need drawing boards, clips and masking tape if it is at all windy.

You will need: at least one large sheet of paper and a marker pen, or a whiteboard that the children can reach; soft pencils, felt-tips, handwriting pens, black wax crayons – any medium which will make a strong line. Inexpensive paper is fine, and use sheets as big as is practical; drawing boards will help give each child enough space, if the whole class is working at the same time.

Lines and movement

It is helpful to link the idea of line with the idea of movement. Ideally, you should be in the playground or the school hall. Ask the children to think up different ways of moving from one point in the hall to another. Children will run, hop, somersault, roll on their sides, shuffle, walk in slow motion, skip, leapfrog. They will have lots of ideas of their own.

Give the children some paper and ask them to think up lines that go with their movements.

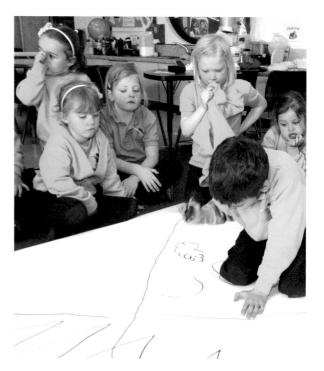

Right: these children found natural lines outside. Why not make a collection of lines? These could include a wide variety of lines from inside and outside, both natural and manufactured (for example ropes, sticks, willow and cords)

Below: using a large sheet of paper on the floor to draw lines

Session 2

Taking a line for a walk

This is a project that helps children talk about a sequence of events.

You are taking an invisible friend for a walk. Only you can see her. Your friend is very lively and never goes anywhere just by walking. She skips and jumps and hops and zigzags. Tell me some of the other ways she can move. Here is a large piece of paper and some wax crayons to draw with. Start anywhere you like on the paper and make a line to show what your friend does on the walk. Remember we can't see her, only the line she makes. You can go anywhere on the paper. Why not draw some of the things you and your invisible friend might see on the way?

Using the line drawings as a prompt, ask individual children to tell the class what their invisible friend is doing and what they passed on the walk. Use a large sheet of paper and wax crayons. Have the children found out how to press firmly with the wax crayons if they want to make stronger colours?

Looking for and drawing lines you can see

Go outside and ask the children to talk about all the different lines that they can see. You could collect lines to bring back to the classroom. Talk to children to focus them before they draw. Children could draw trees in winter, the lines they can see on a building or wall, the horizon line, etc. Children can also make drawings of lines they can see in the classroom. They could use handwriting pens, black biros, soft pencils or black wax crayons. These media will make good clear lines and children can't rub them out easily. This way, you can encourage children to keep going without worrying about mistakes. It may be strange for them at first, but it really does build confidence.

You will need: A4 or A3 paper or strips of paper; clipboards or drawing boards; black felt-tip pens, handwriting pens, black wax crayons or soft drawing pencils. You could fold paper into rows so that each line will be in its own compartment, or leave the children to decide where the lines are going on the paper. Inexpensive paper is fine.

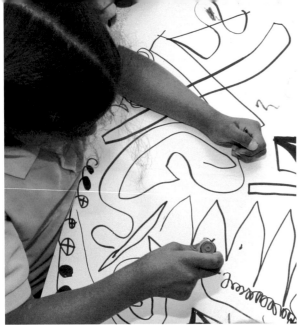
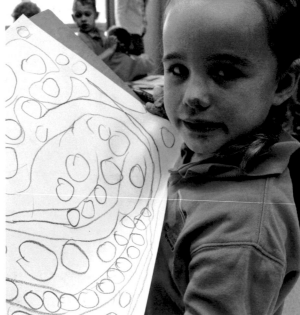

Session 3

Experimenting with marks

Look at the projects on texture. For example, see page 70. Here are some other ideas.

Collect together different examples of all the drawing materials in the classroom that could be used to make marks. Fold large sheets of paper in half to divide them into two. On one side, ask the children to make one mark with each of the materials. Ask them to repeat this again on the second half of the paper; this time, the new marks must be really different from the first set. Ask the children how they made the marks look different. You could extend this project by exploring how some natural and manufactured materials will make marks on paper. The children could also use paint and ink.

Experimenting with marks and movement

This is great fun and very energetic! You could use a roll of paper, rolled out on the floor and long enough so that there is room for each child to have a space to draw. Split the class in half. Stand one half on either side of the paper. If the paper is long enough, the children could all draw at the same time, or it is fine to take it in turns. They will need something to make a mark with. Washable felt-tip or marker pens are fine.

How does a worm move? Let's all move like a worm. Now make a mark on the paper in front of you. Think about the wriggling worm. How does a bee move? Let's all move like a bee. Now make your marks. How does grass move in the wind? Let's all move like grass blowing gently in the wind. Now make a mark like the grass moving in the wind. What other ideas do you have?

Experimenting with marks and sounds

You will need a variety of musical instruments and other objects that the children could use to make sounds. They can also use their own voices. Let the children decide where each mark is going on the paper. You could rule or fold the paper into rows or compartments, but you will need quite a few of these if you want the children to draw one line or mark in each space. In this session, the children have to make a conceptual leap between musical sounds and marks. Ask them to draw the sound, not the instrument.

Listen to this sound. What is it like? A long rattle? Can you make a mark that goes with that sound? Here is a cymbal crash. Can you make a mark to go with the crash?

Listen carefully. Listen to this sound. There is a loud sound, and then a soft sound, and then a loud sound on the recorder. Try a mark or line for a loud sound and then for a soft sound. Now one of you come and make a sound for the others to try. Which instrument or object are you going to choose? You can also make sounds with your voices. We are going to try: high, low, rattling, loud, and very soft. Listen to each sound and make some marks or lines for these sounds too.

You will need: some large sheets of paper; drawing materials that make strong, clear marks. Could the children choose from a variety of drawing media?

Top left: just look at all the different lines we can draw!

Top right: exploring marks inspired by the movement and sounds of bubbles

Opposite: experimenting with marks and movement

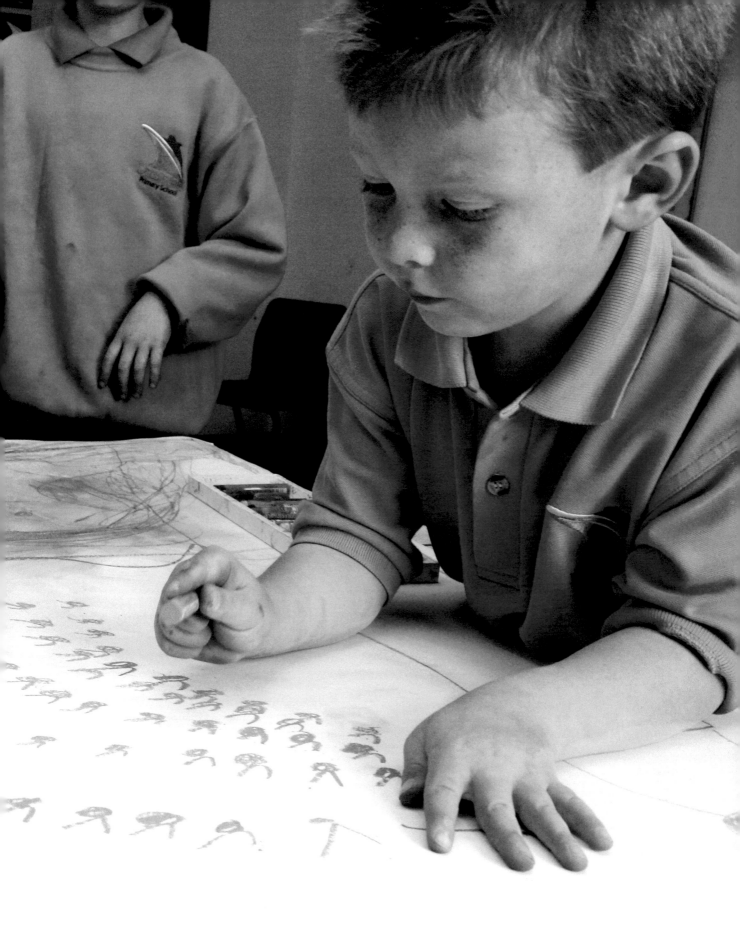

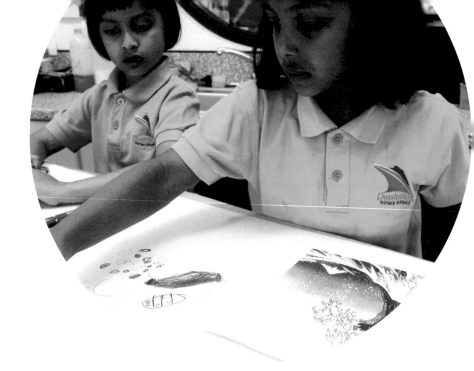

Drawing with line

Session 4

Talking about line and marks in a drawing or painting

Find a drawing or painting with a variety of lines and marks. Perhaps you could look at ceramic decoration or fabric designs. We chose images by the nineteenth century Japanese artist, Katsushika Hokusai.

Let's talk about what we can see. Now let's talk about the different kinds of lines and marks. How do you think the artist made these lines? Could somebody demonstrate?

Let's all make lines in the air just like the artist made lines on the paper. Now you could make your own lines and marks by drawing.

It might help to use a view finder. This is a piece of card with a rectangle cut out. This acts as a frame to isolate part of the drawing or painting, so that the children can concentrate on the lines and marks rather than on the picture.

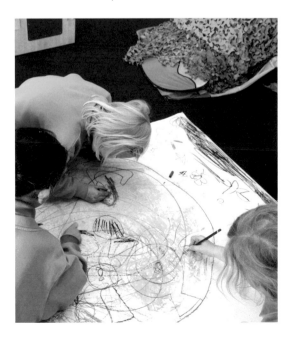

Making a sea drawing focusing on line and marks

I will read you something about the sea. Who has seen the sea? What is it like? How does the sea move? Who can make the movement of a wave? How would you move like a big wave? How would you move like a calm, gentle sea? How would you move like the surf or the ripples or the splashes? What marks would go with those movements? Can you make the sounds too? The artist used lots of different lines and marks and so did you when you were exploring and experimenting with line. Remember how you made the movement of waves. Build up your picture with marks. Fill up the whole paper.

Children in these photographs worked in groups of four. The large sea drawings in pastels are approximately 1.2 metres squared. Ask the children to talk about their work. The initial discussion will help the children decide what kind of sea they are going to paint or draw. They could go on to put other things to do with the sea in their picture. Children will work in a significantly more meaningful way and with enhanced technique, if they first follow a strategy of exploring, experimenting and talking.

You will need: large sheets of paper; pastels or charcoal and chalk; hairspray to fix pastels.

Above: drawing waves after looking at a Hokusai wave drawing
Left: children working together on a large drawing of the sea
Opposite: large collaborative drawing of the sea

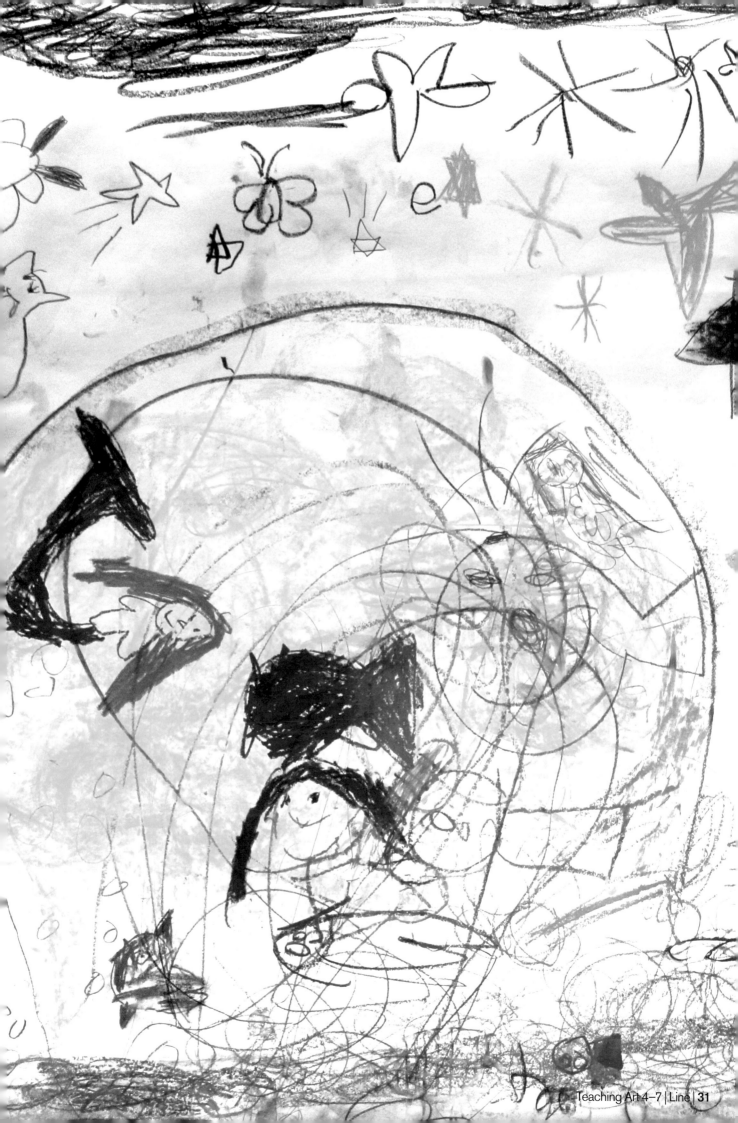

"The counting caterpillar...the radiator...the window... Alex's trousers...the plastic plant pot...tiles on the wall... the computer has a pattern..."

Repeating patterns

Session 1

Repeating games and talking about patterns

Here is a sound. I can repeat it. I can make it again in the same way. Who can make a sound and repeat it? Here is a movement. I can repeat it. I can do it again in the same way. Who can make a movement and repeat it? Let's all make the same movement and repeat it three times.

Here are three different sounds together. I can repeat them. Who can make three different sounds together and repeat them?

Here is a shape I am drawing. I can repeat it. Who can draw a shape and repeat it three times?

Here are two colours side by side. Can I repeat them? Who can put the two colours side by side and repeat them three times?

What ideas do you have for a repeating game?

It is important to make the link between these repeating games and the repetition of shapes and colours that make a pattern on paper.

Look around the classroom. Who can find anything that is repeated and makes a pattern? Let's see how many patterns we can find.

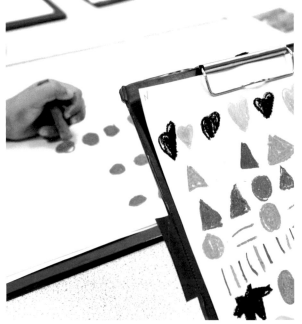

Session 2

Drawing simple patterns in the classroom

Can you draw some of the patterns we talked about? And any new ones you can find? When you are drawing, you will have to look very carefully.

It is a good idea if children have done work on drawing shapes first. See pages 16 and 17. They could also draw patterns that they find outside. They should use A4 paper and clipboards or their sketchbooks to collect three or four different patterns.

You will need: any drawing media that make a strong clear line, for example, soft pencils, black wax crayons and handwriting pens. The children could also use colour right away, although this may make the concept more complicated.

Making your own pattern by drawing or painting

Who can draw or paint a pattern of their own? Has anyone got any ideas about what they could draw to make a pattern? Try to make repeating patterns. Start at the top of the paper and fill up the whole paper with your pattern.

If younger children need help with this, they could draw around shapes to make a pattern. However, it is better if they are free to use their own ideas. Some children will not draw strictly repeating patterns but as this is an imaginative project, let them explore and experiment. You can always reinforce the idea of a true repeating pattern again later. The printing exercise on page 34 is a useful way to reinforce knowledge about repeating patterns.

Investigating natural patterns

You will need to collect natural objects that show a clear pattern. Many of these patterns will be irregular. This is a good talking point. There are some wonderful images of natural patterns. Think about aerial photographs of geographical and geological features, crystal formations, microscopic structures and cells. Children could use a digital microscope to find hidden patterns.

Look at the pattern in the orange I have cut in half. Look at the pattern of the lines that make the grain on this piece of wood. Look at the pattern of feathers on this bird's wing.

Why not draw the patterns you can see? Look carefully and work slowly. This kind of drawing is called a study, or a drawing from observation.

Encourage them to fill the paper. Think big! Of course, some children's natural drawing style will suggest small drawings. This requires some sensitivity to the individuality of each child. Exploring the links between naturally occurring patterns and those which are self-made also supports learning in other areas of curriculum. If children are confident drawing with a range of different media, why not give them a choice?

Top left: making your own pattern

Top right: some examples of natural patterns

Opposite: repeating movements again and again to make a repeating pattern

Printing

Session 3

Practising printing

You will need a collection of objects that will make prints. Try cotton reels, Lego, wooden blocks, etc. Roll out some water-based printing ink on a flat plastic tray. Use three colours. If children are learning about colours, why not use the three primary colours? Put some of the objects in the red tray, some in the blue tray and some in the yellow tray. Tell the children you are going to experiment making prints on scrap paper or newsprint.

Making a simple printed pattern

Here are some sheets of coloured paper. Choose a colour for yourself.

Now choose an object from a tray of coloured ink. Make a print on the top left of your paper. Choose a new colour and make another print next to the first one. Which colour haven't you used? Make a third print in line with the first two. Now, can you repeat the order of the colours to make a colour pattern? It's hard to remember the order, so keep checking your paper to decide what is coming next.

This is an opportunity to reinforce the concept of a regular repeating pattern. Make sure there is plenty of space on the walls, so that the prints can be pinned up to dry as soon as they are finished, or use a clothes line. Children can produce a great many prints very quickly! They will also be able to see their prints clearly. Make a large display of coloured patterns from the class. There is no need to mount the work; just pin each piece close up against its neighbour until you have a large block of prints. This can be very colourful and very exciting for the children to see.

Talking about the patterns

Now we can see the printed patterns, which ones work really well? Why? Which patterns look good? What could you do to make the printed patterns even more interesting?

You will need: water-based printing inks; plastic trays and rollers; scrap paper; damp rags or sponges for sticky fingers; objects to make prints with.

Above: a printed pattern
Left: rolling out the ink

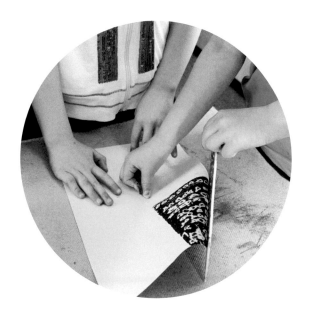

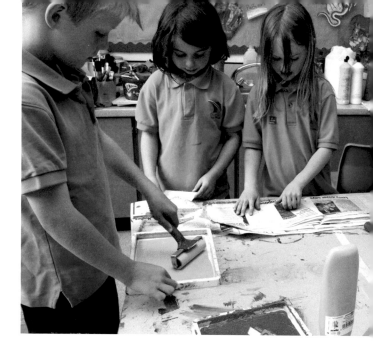

Session 4

Experimenting with printing using polystyrene tiles

Children could use their investigation of natural pattern to design a print that they can make with polystyrene tiles. First of all, they need to find out about the process. You will need to give the children a simple demonstration. Then let them experiment to discover problems and investigate possibilities for themselves.

On a small polystyrene tile, practise using a blunt pencil to make some lines and shapes. If you press too hard you will go through, too lightly and you won't see the print.

Squeeze a thin sausage of ink onto a flat plastic tray. Roll this out with a roller to spread the ink evenly across the tray.

Put the tile flat on a half sheet of newspaper with the marked side up. Roll some ink on the polystyrene tile with the roller. Cover the whole tile. Don't forget to go over the edges. Keep the tile steady with one finger. Your finger will get ink on it, but you can always use the rag or sponge to stop your hands getting too messy.

Place the tile ink side down on some coloured paper, and press flat with a clean roller.

Gently peel off the tile and look at your print.

Put a clean sheet of newspaper over the inky one. Use a rag to wipe your hands.

Top left: holding the paper steady whilst peeling away the tile
Top right: every time you ink up a tile, turn a sheet of newspaper
Right: placing the tile carefully on the paper

You can now repeat your print and make a pattern. Remember to get the tile the right way up! Think carefully about where it should be on the paper.

Talk about the problems with the children. They will need space to work. Encourage them to have a dirty side and a clean side to their working area. This can be marked with a line of masking tape. You will need storage space immediately for the wet prints. Why not pin them up for everyone to see?

You will need: dense polystyrene tiles for printing, which you can buy from educational supply companies; soft blunt pencils to press a design into the tile; water-based printing inks; plastic trays; rollers to roll out the ink; clean rollers to roll over the back of the tile to make a print; coloured paper; damp rags or sponges for sticky fingers; half sheets of newspaper; masking tape.

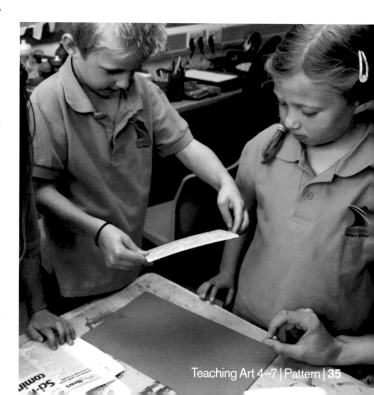

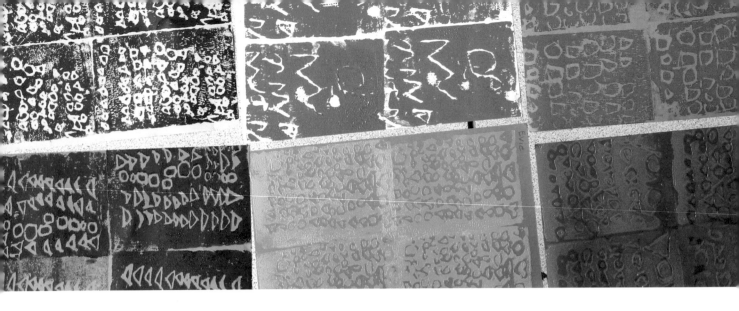

Session 5

Designing and printing a pattern

You need to decide the size of tile that each child will need to make a print.

Use this as a template and ask the children to draw several adjacent tile shapes on their paper. The children can then draw their design in the first space. They could get ideas from the natural patterns that you originally collected and talked about. The children will also need to be able to look back at their drawings of natural patterns.

Transfer your design onto the tile by drawing on the tile with a blunt pencil. Press firmly, but not so hard that the pencil goes all the way through the tile and makes a hole. If your lines are faint go over them again. Now you can print a pattern. You will need lots of space. Why not work with a partner who can help you? Then you can help your partner.

Choose a large piece of coloured paper. You will need to print your tile several times to make a repeating pattern of prints. Remember to get the tile the right way around. Remember to place it carefully next to the first print to get a regular pattern.

Is there space to pin the prints up to dry? This activity takes up a lot of room. It is very rewarding but labour intensive. Talk about the prints the children made and the process they used. Which printed patterns look good? Which work well? You can reinforce knowledge of the equipment and the process of printing. The children in the photograph worked in a team of four. There was an inker-upper, a printer, a tile mover and a supervisor who kept an eye on making sure everything stayed clean and organised.

You will need: all the equipment for printing set out on page 35; paper and drawing materials for the designs. It may confuse children to use more than one colour for their design at this early stage. Two- and three-colour printing would be a way to ensure progression as children go through school.

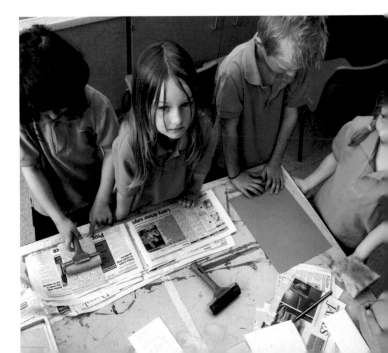

Above: finished patterns laid on tables to dry

Right: working together

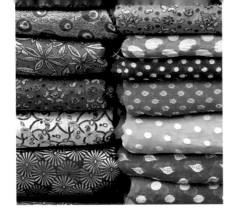

Fabric design

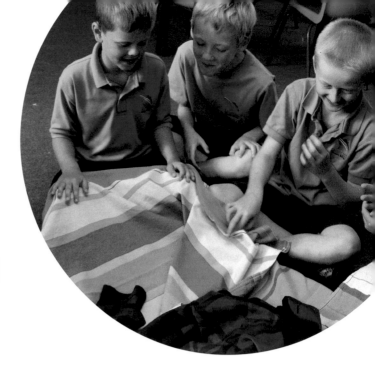

Session 6

Collecting shapes or patterns

The children will be using shapes all through this project. See pages 16 and 17 and the sessions on shape for ideas to act as warm-up exercises for their explorations of pattern. Or, if the children have recently worked through the earlier sessions on pattern, they could begin this project by investigating natural or made patterns in the classroom or outside. Provide a rich variety of natural or made patterns for the children to explore.

Talking about patterns in fabrics

Here are some different fabrics I have collected. Just look at all the patterns. Let's talk about what you can see. We can talk about the colours and the shapes. Where can you see colours repeated? Where can you see shapes repeated? Is there anything else which is repeated? Which patterns do you like the best? Can you say why? We could find out which pattern is the most popular.

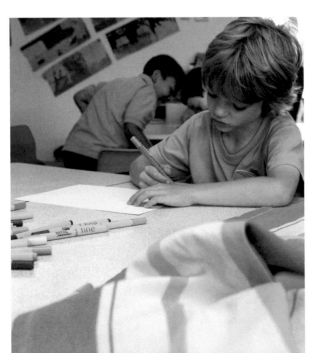

Drawing fabric patterns

These fabrics have patterns. You are going to draw some of the patterns. Each group will have its own pile of patterned materials to look at. You need only draw the pattern and only enough to show what it is like. You don't have to draw it all! You will be using wax crayons. You can choose which colours you think will be the best to go with the pattern you are drawing. You have a large sheet of paper so that there is room for at least two different patterns. You can colour both the shapes and the background.

Talk with the children about the finished drawings. Make an informal display so that they can clearly see their work. You will be using these drawings to help them make a design. Show the children how wax crayons or oil pastels make strong colours when you press firmly and draw slowly. This will help them to make their pattern collections look really striking.

Draw the outlines of the different shapes that make up the pattern. Don't worry about mistakes. The most important thing is that we can see a number of different pattern ideas on your paper.

You will need: A3 paper and clipboards or sketchbooks; a choice of coloured and black wax crayons, oil pastels, felt-tip pens, handwriting pens and soft pencils; a collection of patterned fabrics.

Top left: collection of patterned fabrics

Top right: exploring patterns in fabric. This fabric is made on traditional looms in French Catalonia

Left: drawing fabric patterns

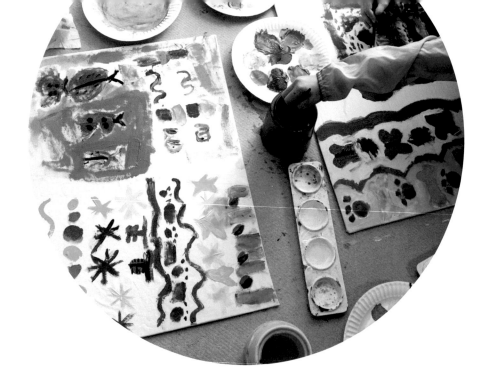

Session 7

Designing

Do the children know what design means? If not, now is a good time to introduce them to the concept.

What would you do first to make a design for a piece of fabric? How could you plan a pattern for a fabric design? Why do you think we are going to make a design? All the fabric patterns we have seen have been designed. To start with, an artist made a drawing to help plan the patterns we can now see in the fabric.

First of all, show the children fabric crayons. They will eventually use these to draw their design ideas onto some white fabric, cotton or polyester.

We are going to use some A5 paper for our design. Look at the fabrics and look at the patterns that you drew. You can look at your own or someone else's. They are all up on the wall so that you can see them. Use the wax crayons to try out an idea. Fill up the whole A5 paper with your pattern. If you want part of your design to be white, use the white wax crayon. Have you coloured every part of your design? When you have finished your designs we are going to use them to help us cover this white material with colours, shapes and patterns.

You will need: A5 or even A6 paper (the younger the children are, the more difficult it will be to fill a piece of paper with a pattern, which is why smaller sheets can work well); coloured wax crayons. Children should experiment first to find out how to press firmly to create strong colours and lightly for paler effects. Coloured felt-tip pens for children who enjoy making a small and detailed design; fabric crayons.

Choosing the designs

The project continues with the children looking at all the designs. One design could be selected from the whole class to make one large piece of patterned fabric. This could be the size of a curtain or tablecloth. Or children can work individually, in pairs or threes to create a sample of finished fabric. All the designs should be displayed or laid out on a table, so that they are easy to see.

Have a good look at all the designs. Which do you like the best? You can talk to your friends, but you must each make up your own mind. Now we can have a vote to choose the design that will be drawn onto the large piece of fabric.

Children could even contribute their individual designs to make a patchwork of different patterns on one large piece of white material. In any case, every child will have the chance to see their own design reproduced on fabric.

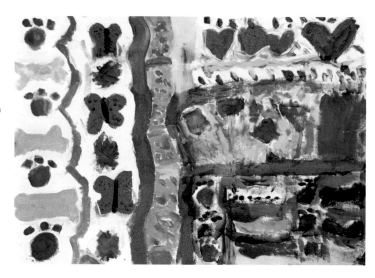

Top: using fabric paints
Above: a design painted onto fabric

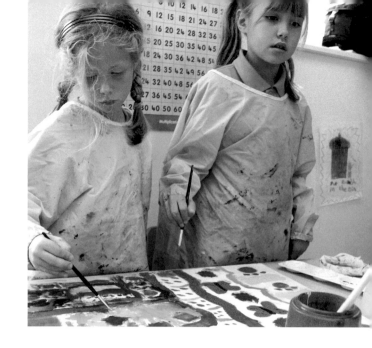

Session 8

Drawing or painting the designs on the fabric

Fabric crayons are easy to use. You will get stronger colours if you let children draw straight onto the material. Fabric paints have a wonderful intensity if used neat on white fabric. It is easier to draw or paint on the fabric if it is stretched over a thin rectangular sheet of plywood. We used a drawing board which was a piece of 3 mm plywood cut to 62 cm by 90 cm. Use a staple gun to tack the fabric onto the back of the board. Work from the middle of each side to the corners, stretching as you go. Try to smooth out all the creases.

Displaying and talking about the process and the product

We can make a display to show all the work that was done in our fabric design project. Here are the shape and pattern explorations, the patterned fabrics that I brought in for you to see, the drawings of the patterns you found in the fabrics, your designs, and the finished pieces of material. There is a lot to talk about! This is a design process. You have been designers!

Above: using fabric paints

Below: a display of fabric patterns made with fabric crayons

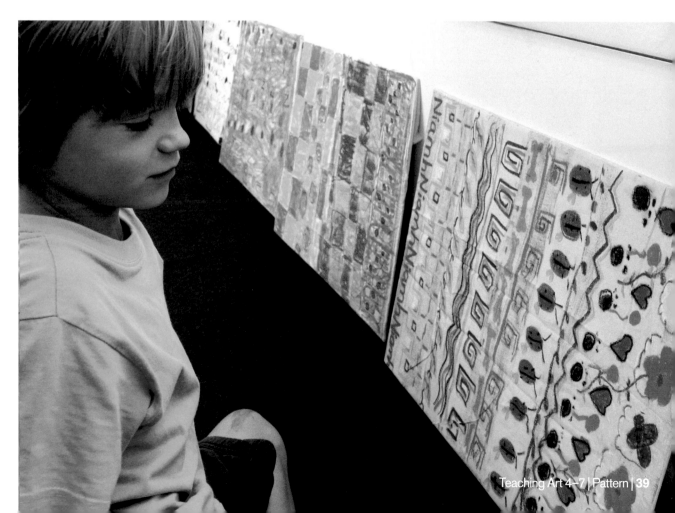

*"I made green…I made orange…I made light green…
I made brown. But how do you make brown?"*

Exploring colour mixing

Session 1

Making handprints

*Here is a tray of red paint, here is a tray of yellow paint, and here is
a tray of blue paint. Put your hand in the yellow paint. Press it onto
the paper to make a yellow handprint. Now put your other hand in
the blue paint, and make a blue handprint. Now rub your hands
together. What is happening? What colour are your hands? They
have turned green. Magic! Make two new handprints with your
green hands. Wash your hands. Now you could try yellow and
red, or blue and red. Can you remember how to make green?*

You could call the three primary colours 'magic colours'. But why not
introduce the correct vocabulary – primary and secondary colours?
These handprints make a great display as a frieze around the room
or in a block on one wall.

One note of caution: there can be a problem mixing purple with
paints usually found in school. Purple often looks closer to brown.
Use crimson red and bright blue to find a better looking purple.
Try having two different reds, two different blues and two different
yellows to make a full range of hues.

You will need: strips of paper; a bucket of water and a towel for hand
washing; trays of red, yellow and blue paint; extra adult help.

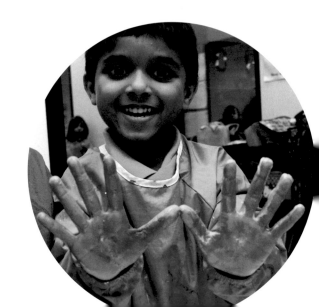

*Right: rubbing a blue hand
and a yellow hand together
to make green*

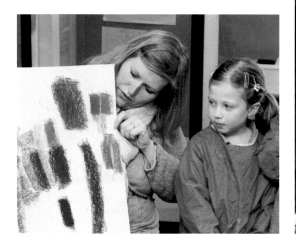

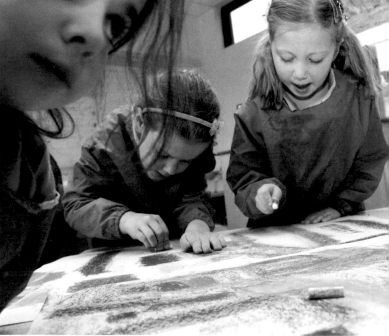

Mixing pastels

Now we can experiment with pastels. Look, I can put a patch of yellow on the paper. What do you think will happen if I add some blue over the top? I can mix it with my finger. What do you think will happen if I mix the yellow and red?

Now you can try mixing any two colours together. Make good, large patches; patches not pictures! You could find out what happens when you add white. Fill your paper with colour patches.

Talking about colour experiments

Which colours did you use to make this green? How about this orange? Here is a really pale red, how did you make that? Can you remember?

Do any of your colours remind you of anything? We could make a list of all your ideas. Look around the room. Which colours could you make by mixing?

If you pin up the pastel experiments in a block they make instant play of children's colour explorations.

You will need: soft chalky pastels or oil pastels (if you want the children to find a wide range of colours, you will need to select two reds, two blues, a yellow and a white) – these can be broken into small pieces to share around; firm-hold hairspray to fix the soft pastel experiments (this will stop them smudging too much); large sheets of paper to encourage collaboration and inventiveness.

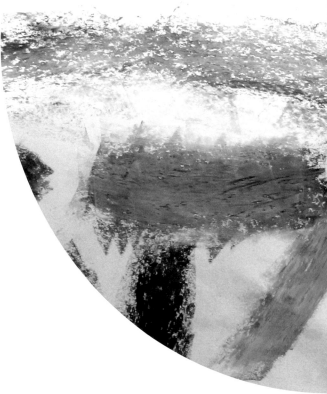

Top left: talking about the experiments

Top right: mixing colours with pastels

Right: look at the colours we mixed with the pastels

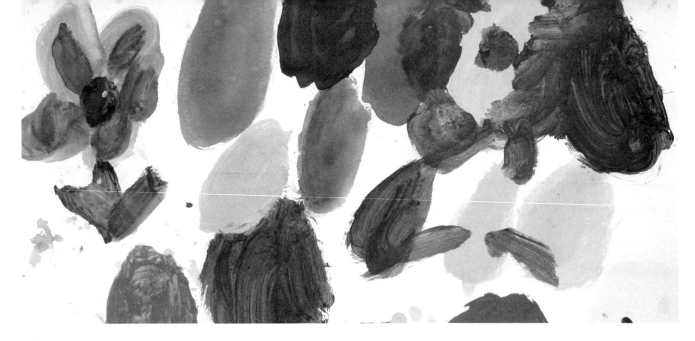

Session 2

Simple colour mixing using paint

Here are the paint colours: two sorts of red, two sorts of blue, and two sorts of yellow. Here is a mixing palette. Here are the brushes, one thick and one thin. Here is some water. Here is a rag. Here is the paper you are going to paint on. What colours do I need to make green? I can take a little yellow paint with the brush. I am putting the yellow in the mixing palette. Now I need the blue. What will happen if I put this dirty brush in the blue? The brush has yellow paint on it. What can I do to stop the yellow paint spoiling the blue paint? I can wash the brush in the water. What's happening now? The brush is all wet and dripping everywhere. That will spoil the painting and make the table wet. What can I do? Wipe the brush with the rag. Now I have a clean brush, I can get some blue paint. I can add this blue paint to the yellow in the mixing palette and mix them together. What do you think will happen? Now I can paint my green on the paper. I am making quite a big patch.

I could try to mix another colour. How about orange? What colours do I need? Red and yellow; but wait, what must I do before trying to get some red with the brush? WASH AND WIPE THE BRUSH. You must always wash and wipe your brush. You must try to keep each paint colour clean.

Okay, now you can make a sheet of colour patches. Remember: paint patches, not pictures.

Young children will often forget to paint the colours on the paper because they become so absorbed in mixing colours.

You will need: ready-mix paint; containers for different colours; mixing palette; thick and thin brushes; water (large, half-full water containers are best); rags and/or sponges; paper (use thicker, better quality paper to show the colours at their best).

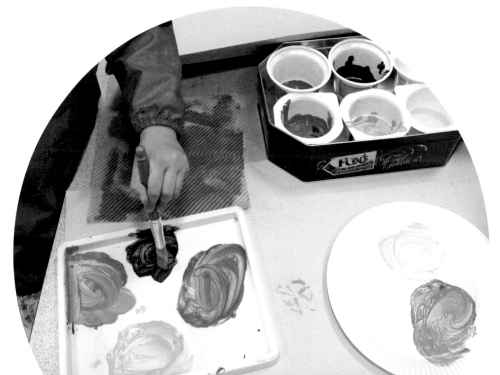

Above: colour mixing with paint

Right: using a mixing palette

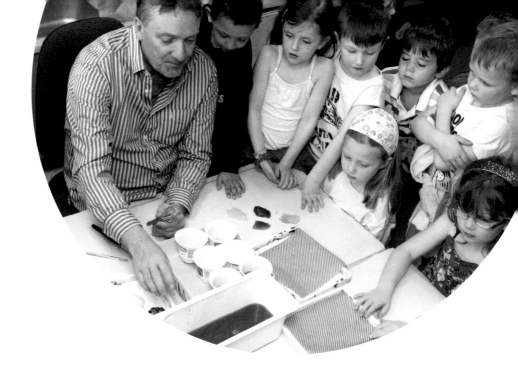

Notes about mixing colours using paint

For children who are four and five years old, use one large plastic container of water for each group. This sits in the middle of the table. Fill it half way. It will be too heavy for children to move easily (or knock over) and the water will not need changing as often. An adult will have to change the water.

If children have individual water containers, they need to change the water when it looks like cold tea.

Give children a thick and thin brush right from the start. It's impossible to make small, delicate marks with a thick brush.

It is much better if the mixing palettes are flat. This encourages children to cross-mix colours they have already made. You can use anything that is easy to wash. The tops to freezer ice-cream containers are cheap and easy to collect. Encourage the children to use all available space in the mixing palette before washing it clean.

Ready-mix paint, rather than powder paint, is easier for children to use when they are exploring colour. The commercial six-well containers are fine for holding ready-mix paint, but small containers placed together in a tray, box or tin also work well. For example, use yoghurt pots and a freezer-size ice-cream container.

A typical minimum selection of colours would be: white, lemon yellow, yellow ochre, bright blue (or a blue that tends towards violet), turquoise (or a blue that tends towards a greener hue), bright red (or a red that tends towards orange) and crimson (or a red that looks like magenta or tends towards violet). Only give children black when you are sure they are totally at ease with this process.

Above: the author shows a Year 1 class how to mix colours with paint

A rag is essential to wipe wet brushes while children are painting. Some teachers prefer sponges. Paper towels are not suitable.

If you want bright colours, you will need cartridge paper or even thin white card. The pigment soaks into cheaper paper, which will also buckle and crinkle when wet. However, if resources are precious, save your good paper for making a painting and use a cheaper kind for experiments. An alternative is to make the colour experiments on small sheets of newspaper. Ask the children to cover every bit of print in different colours. This will be very soggy to start with, but is perfectly robust when dry.

If children are making a painting, add some scrap paper for try-outs and colour testing.

This process is not intended to replace any other forms of painting you are already using. It is a supplement, a way of introducing young children to mixing colour. Of course there are other versions of this painting process which work well. However, I have found that these techniques and teaching strategies release children's creative use of colour, because they slow children down, putting them firmly in control of what they are doing. There is no loss of spontaneity once the children are practised at mixing colour. Seven year olds, even six year olds, say, "We want to mix our colours. We don't want to paint like babies."

Colour in fruit and vegetables

Session 3

Drawing and painting fruit

At first, use different fruits that have clear and distinct colours. Apples that are both red and green, or peppers that are orange and green provide a more advanced stimulus. The aim is to make a link between the colour-mixing experiments and colours that the children can see.

Remember the colour mixing experiments? You know how to mix colours. Ask a friend if you can't remember how to mix a colour.

Here is an orange. You could mix a colour for the orange and paint the orange on your paper. What about this apple, a Granny Smith? It's green all over. Here is a watermelon. What colours can you see in this watermelon? Red? Yes, but there is some green too. Make a painting or drawing of the watermelon and show all the colours you can see.

We are not worrying about shapes here, but if children have already done work on shape this will help them. Once they get the idea, they can paint or draw a line of different fruit and vegetables on strips of paper or they can group similar fruit or vegetables on the same paper. Can they add in the detail they can see? Ask them which brush is best for detail.

They could record the colour changes of fruit as it ripens and decays. They could also paint flowers in the same way. This method could be used to record changes in colour for a science project.

You will need: all the equipment for painting (see pages 42-43) or use pastels (see page 41); fruit and vegetables.

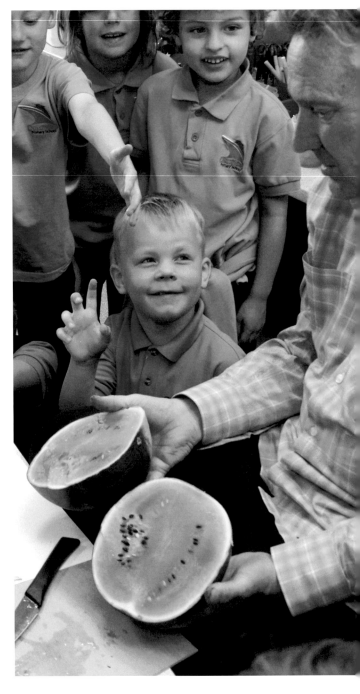

Top: recording colours with pastels

Above: cutting open fruit and vegetables to reveal hidden colours!

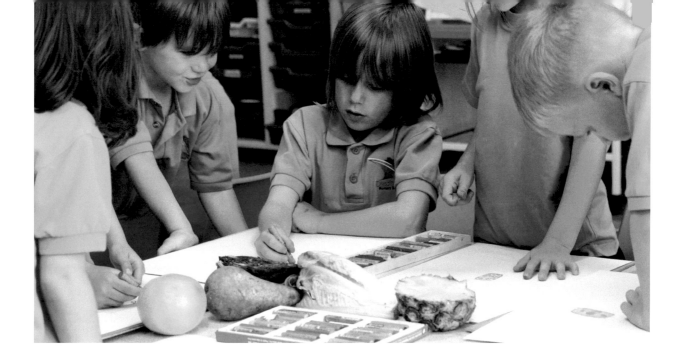

Drawing and painting a still life

Before thinking about colour, first talk about the shapes of the different fruit and vegetables. See page 16 for ideas about helping children become more aware of shape. Explore the shapes by drawing as on pages 21 and 22.

You could talk about a still life painting, perhaps one by Cezanne. See page 46 for ideas about talking about a painting. After you have looked at the painting, you could collect some of the colours in it by colour mixing with pastels or paint.

Talk about the still life you have made in the classroom. You may want the children to think about the way the fruit and vegetables are arranged. See page 58.

Here is some advice for making a painting. Ask the children to mix a very pale colour in the mixing palette. They can use the pale paint to draw the arrangement of fruit and vegetables, using a thin brush. Tell them that if they make a mistake, they can easily hide it by painting over the pale lines. This is much better than using pencils. Paint is wonderful because you can paint over areas you want to change or improve. The only problem with 'painting over' is that sometimes the paper gets very wet. The children will have to wait a little until very wet areas get dry.

Encourage them to think big and fill their paper with colour. After filling the paper with the basic colours and shapes of the still life, some children will be able to paint more detailed areas.

The children could make up their own background. Patterned or plain? Simple colours or multi-coloured? Leave it up to them!

Finish off the project by having an informal exhibition. You could lay paintings out on the tables or the floor. Talk about the finished work. Looking back at earlier explorations, collections and experiments really helps children to understand what they have been doing.

You will need: all the equipment for painting (see pages 42-43) or use pastels (see page 41); fruit and vegetables for still life arrangement.

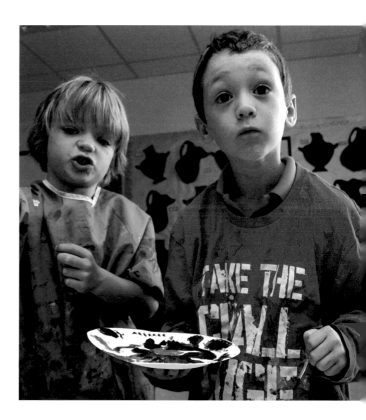

Top: drawing a collection of fruit and vegetables, focusing on colour

Above: paper plates make good mixing palettes

Making an imaginative painting

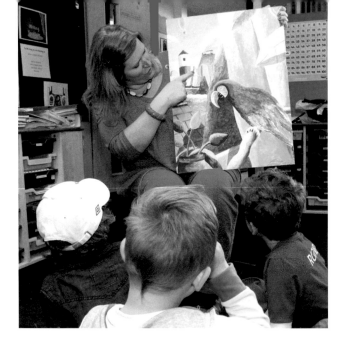

Session 4

Talking about a painting

Ask children to tell you about everything they can see in a painting by a landscape artist. We used a painting by the Welsh artist, Emrys Williams. If you are hunting for an image to use, why not try searching an online database? For example, the Tate Gallery has a searchable image bank of their collection. Use the term 'landscape' to find a wealth of examples to show children. Many landscape paintings are available as prints to display in the classroom. Make a list. Then go on to talk about the colours.

What colours can you see? You said you could see green, are all the greens the same? Can someone point out a dark green? How about a light green? I can see different yellows and oranges too.

You can build children's colour vocabulary. Children could experiment and mix some of the colours they can see in the painting.

How does the painting make you feel? What's happening in the painting? What would you feel like if you were there in the painting? What do you think about the painting? Do you like it? Do you dislike it? Can you say why? Perhaps you like some things about the painting but not others?

Making an imaginative painting

Spend as much time as is practical discussing children's different ideas for an imaginative painting. If you have been discussing paintings, point out how most artists don't leave any gaps in their work. They fill their paintings with colour.

Children develop an increasing control over colour and paint because colour mixing slows down the painting process, allowing them to be more thoughtful about their work. They should practise mixing larger amounts of paint. As they progress, they will gradually become more and more confident.

You will need: all the equipment for painting (see pages 42–43); prints or examples of paintings.

Above: talking about a painting by the Welsh artist Emrys Williams

Below: imaginative painting using acrylic paint

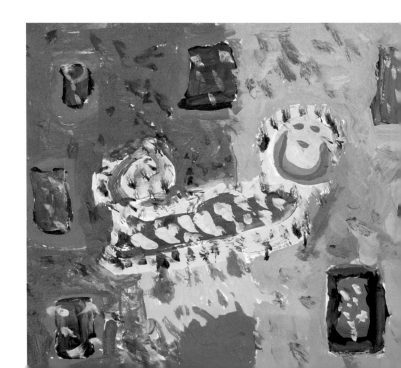

Making a drawing or painting with a focus on greens

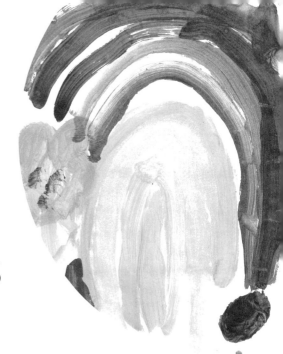

Session 5

Green experiments

Adapt this project to fit the following themes: a garden, the nature reserve, house plants, or an indoor garden. First of all, spend plenty of time talking about what the class can see.

What can you see? Let's see how many different things we can pick out. I will make a list of everything that you mention.

Now, I want you to think about all the greens you can see. Are all the greens the same? What are some of the differences? Who can tell us where they can see very dark green? What about a very pale green? Where can you see a yellowy green?

Ask the children to make a sheet of green colour experiments with pastels or paint. Ask them to remember: no pictures, just patches. Some children will make a great many different greens.

If the children are used to colour mixing, they could use black. They will need it to make the darkest greens. Leave out the black at the beginning, however, if you feel they would use it without thinking first.

If you are confident about their experience with colour, children could have access to all the colours in the pack. You could ask them to experiment, and find different ways to change the colour of a green by mixing it with different colours.

Turf and natural materials make small environments in the classroom. Work from these mini-landscapes in the same way. Add some mini-beasts for excitement. Empty snail shells do not move too quickly!

Talk about all the different greens the children have mixed. You could compare their experiments with what they were observing. Although the focus of this project is green, in an urban or industrial environment other colours could also be explored.

Painting and drawing a landscape

To make a landscape or garden drawing outside, you will need drawing boards. Use masking tape on the corners if there is a breeze. After all the preparation, the children will have plenty of ideas about what to draw. After reminding them to look carefully, ask them to think big. Encourage them to fill their paper with all the colours – especially the greens – that they can see. If the weather is unsettled, make sketches outside and take photographs. The children could work from these in the classroom.

Talk about the children's work. Sometimes it is difficult to do this properly at the end of an art activity if time is short, but take the opportunity to review what children have achieved and discuss the problems they discovered at the earliest opportunity. Look at the landscape painting by an established artist again. Look back at the colour experiments. Have an informal exhibition by laying the work along the floor of a corridor.

If you display finished work, put up the experiments as well. It really shows the children how much you value that work, too.

You will need: pastels; off-white sugar paper; drawing boards and clips or masking tape for windy days; firm-hold hairspray to fix soft pastel drawings; all the equipment for painting (see pages 42–43).

Above: exploring greens in paint

Other ideas for working in colour

Of course there are almost limitless possibilities for children to explore colour. Here are just a few.

One class created an installation of coloured butterflies and concertina caterpillars. Children explored the huge variety of colour and pattern visible on butterfly wings before deciding to create this temporary butterfly garden by colouring hundreds of butterflies. Some children used the computer to make their butterfly ideas.

The work on page 38 is made with fabric paint on cotton stretched over an A2 drawing board. Children had been thinking about creating patterns, some of which were patterns of colour.

The children created costumes at home to wear on a special day all about butterflies and caterpillars. It was a great excuse to take delight in colour! Everyone raised money to support a local cancer charity. On a different occasion, the children had a colourful clothes day on which they wore the brightest coloured clothes they had.

Colour can also be very subtle and surprising. Four and five year olds made bubbles and were astonished to find that bubbles have so many colours almost hidden within them.

Above: butterfly and caterpillar installation
Below: colourful clothes day

Top: looking at the colours in soap bubbles
Above: butterfly and caterpillar costumes
Right: drawing bubbles

Form

5

*"My cube is squashed a bit but it has a hole in it…
and my cylinders are fat…but look, I can make
an octopus!"*

Form and clay

Session 1

Talking about simple forms

*Here is a sphere, here is a cube. Can you see any differences
between them? Here is a pyramid, here is a cone. Can you see
any differences between them? Here is a cuboid, here is a cylinder.
Can you see any differences between them? Which of these forms
are curved? Which of the forms have flat sides? Is there a form that
has no edges?*

Making a simple form in clay

This is a good way to begin to use clay. You can introduce the
process as outlined on the next page. We are substituting the word
'form' for '3-D shape', a phrase often used in maths teaching. Some
children find that using the word 'shape' to refer to both two- and
three-dimensional objects is confusing. The word 'form' really helps
to clarify the difference.

*First of all, who can find a way of making a sphere? Experiment.
Now, try a cube…a cylinder…a pyramid. Keep practising until you
have a set of simple forms.*

*Who can tell everybody how they made a sphere? What about
the pyramid? Did anyone use a clay tool? How did you use it?
What parts of your hands did you use?*

Using clay

Red earthenware is inexpensive clay. Use buff-coloured clay if you
want to glaze or paint the objects bright colours. It is best not to mix
different clays together.

Prepare the clay in advance. For these projects, use clay straight from
the bag. Estimate how much clay each child or each group of children
will use. Put the portions of clay in plastic food bags and seal them
tightly. This means you can hand out clay to the children without
anyone getting covered in clay before they start work. Tell the children
not to open the bags until everyone is ready. The clay will stay moist in
the sealed bags for a considerable time.

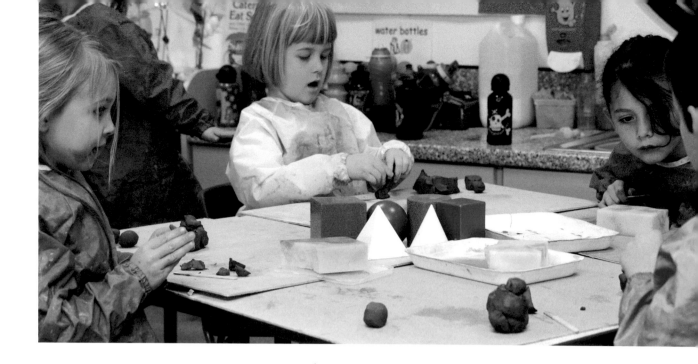

Give each child a wooden board to work on. Some teachers prefer to have one side of the board covered in hessian-type material to prevent the clay sticking to the wood. Have a selection of clay tools available, or use old cutlery, lollipop sticks, etc.

Talk about what clay is like. As you handle clay, it quickly starts to dry out, cracks appear and flakes will crumble off. Show the children this. They need to know that the more they handle clay, the drier it becomes. Observing changes in clay over a period of time could be a science project. Try leaving the clay in the open air, in a paper bag, in an opened polythene bag and in a sealed polythene bag. Ask children to observe the changes that take place over a number of days. The fact that clay dries out when it is handled presents a problem. Water, clay and very young children do not mix very well! There is a way of keeping clay just moist enough to handle, however. Have a damp (but not wet) sponge in a polystyrene tray, one for each child. When the clay feels dry, or their hands are dry, the children can press their palms down onto the sponge. The sponge should be just damp enough so that it does not drip. The children's moist hands will keep the clay in a good condition for their work.

If you want to keep the clay moist enough to work with from one day to the next, you will have to seal any unfinished work in plastic bags.

For best results, you need to fire the clay. Make contact with your local secondary school art department, or try colleges or universities near by. They may help you out, if you only need to fire work occasionally. Children should seal the clay by painting first with a mixture of PVA glue and a little water, before painting their objects as appropriate. One biscuit firing will be enough. Glazes are a luxury.

The clay can also be left unfired. It will be very brittle, but at least the children can see their work displayed. Shoe boxes are useful storage as well as for moving the objects around, as they stack easily. You can get at least two objects in one box with plenty of packing material. Fibre clays do not need firing, but they are expensive and not nearly as satisfying to use.

Talking about how to change a simple form

Use forms that the children have already made, before they have dried out. If need be, you can keep them sealed in small plastic food bags from one day to the next. If you want to join two pieces of clay together, you need some **slip**. This is clay glue made from clay and a little bit of water. Stir this around in a small pot until it takes the consistency of thick double cream. Then show it to the children, explaining that they must use it like glue if they want to join two forms together. They will need a brush to apply the slip.

Here is a cube made out of clay. What can I do to change the cube? Here are the clay tools. How could I use these to change the cube? How would I make a hollow? How could I make a sharp point? How could I put a hole through the cube? How could I round off the sides? Can I make it wider or taller? What could you do to change this sphere? Why not join two forms together? We can then go on and make even more changes.

You will need: simple forms such as a cube, sphere, etc.; clay, either buff coloured or red earthware; plastic food bags; wooden boards for children to work on; clay tools; PVA glue (optional).

Above: finding out about clay by exploring simple 3-D forms

Session 2

Experimenting with clay forms

Children should begin by making some simple forms. Two or three larger forms will be more useful than lots of small ones. They can then make their own imaginative sculpture.

Remember all the ideas we had for changing forms? See if you can make changes to the simple forms you have already made. You could make holes, hollows, sharp edges, bumps, curves, or anything else you can think of. Why not join two forms together? It doesn't have to look like anything you know. Just have fun making your own imaginative form. One person might not have much clay. But if three or four of you work together to combine your ideas and clay you will be able to make something big.

Talk about all the different forms the children have made. Keep a note of the vocabulary for Session 5, 'Talking about a sculpture'.

You will need: the materials and equipment described for using clay in Session 1, page 51.

Top: starting by making simple forms will help children develop an understanding of sculpture. This boy has decorated his clay work. Sculpture is also about how the surfaces look and are treated

Right: beginning to work with clay

Coiling a pot

Session 3

Talking about objects made from clay

One way to start the project is to look at a coil pot. Coil pots have been made throughout history in many different cultures. You could also discuss different objects from the home that are used to contain liquids such as vases, teapots, jugs, etc. Pick ceramic items. Talk about the different forms they take and the fact that they are made out of clay.

Practising making coils

This is also a good way to start using clay. You will need all the equipment for using clay. See page 51 for detailed advice.

Here is a thick wax crayon. Can you roll out a sausage shape that is the same thickness as the crayon? Use the flat palm of your hand to roll. Try to make the sausage the same thickness all the way along. Keep practising; one problem is that sausages can get too thin and break.

Now here is a length of paper. Can you make the sausages the same thickness as the crayon and as long as the paper? You can use the paper to measure your sausage. You can cut the sausage if it is too long. These sausages will become our coils. Make five or six.

The short side of an A4 sheet is a good length. We found that children enjoyed working in twos or threes to share the tasks of making the coils and coiling the pot.

Joining the coils to make a coil pot

Are all the coils (the sausages) the same length? Have you made five or six?

Take one coil and make it into a circle. Join the ends together; remember to use a little bit of the slip, our clay glue. Smooth down the join. Make a new circle. This circle will go on top of the first one. Use a little slip to glue them together, Build up the coils until you have a cylinder. Use a little slip every time you want to join two bits of clay.

Put one hand inside the cylinder and press your fingers gently against the side of the coils. Now very carefully use a flat clay tool to smooth down the outer side of the pot.

Young children of four and five, for example, will find smoothing down the coiled cylinder very difficult. Why not just leave it as it is? It is useful to talk about the problems as you will reinforce knowledge about the process by asking the children what they found difficult.

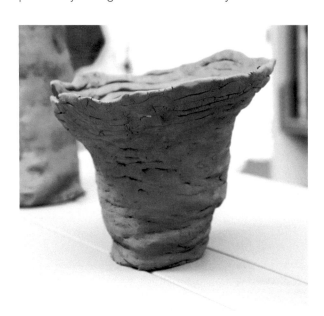

Above: coiling a pot from a spiral base

Right: pots can have many different forms

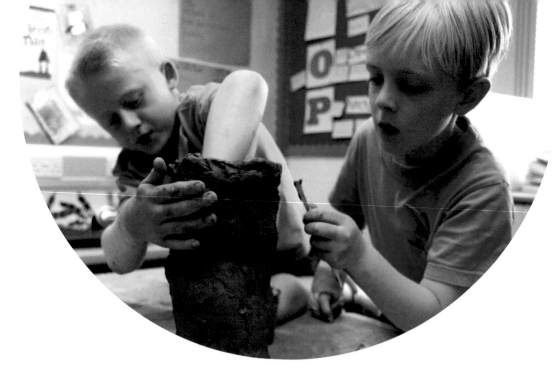

Session 4

Working together to make a large coil pot

Everyone can work together to make a bigger coil pot. You will be working in groups of three or four. Take turns to make the coils and build the coils into a pot. After a while, you can swap jobs. Start by making a spiral base 8–15 cm in diameter. We are going to make our pot by making a spiral of coils, round and round, higher and higher. Don't make the coils too long, or they will become difficult to handle.

When you have coiled the first length on top of the base, keep adding more coils. You must remember to use slip to join the ends each time you add a new coil. Don't forget to use slip on top of the last coil on the pot, before you add each new bit of coil. And remember, too much slip will make the pot clay slippery and hard to work with. Go slowly, so that it looks good.

Don't let the pot get too big without smoothing the sides, but don't touch your pot more than you have to. Remember, don't make the coils too thin. If the pot is too tall and thin, the walls will become unstable.

The younger the children, the more help they will need. For example, four year olds will need an adult on hand all the time. But it is amazing how much they can do on their own.

Decorating the pot

Children could decorate their pot by making marks, lines, or patterns in the side. To practise ideas, ask them to experiment on a small slab of clay (see page 73). Practise making marks and patterns in the clay with different tools and objects. Children could also come up with an idea on paper first. Why not use letter forms as a starting point to make patterns? Perhaps the children could decide which patterns could be used to decorate each pot. Leave the pot to dry a little before decorating it, although it must be soft enough for the children to score the pattern onto the side.

You will need: all the materials and equipment described on page 51.

Above: everyone can work together to make tall pots

Right: working together with coils

Construction

Session 5

Talking about a sculpture

Artists who work in three dimensions use many of the qualities associated with form. Their sculptures are difficult to talk about through photographs; because much of the essential three-dimensional quality is missed. Ideally, you will want to discuss actual sculpture. Have you or your colleagues any sculptural objects at home? Can you visit an art gallery? Are there any examples of public sculpture near by? Places of worship and civic buildings often have sculptures. Is there a sculptor who you could ask to visit the school? If all of this is impossible, photographs are better than nothing.

Here is a sculpture. What can you see? Let's talk more about the form of the sculpture. Remember, this is how we talked about the forms that you made. You made sculptures that were flat, narrow, wide, hollow, curved, rounded, smooth, sharp, thin, tall, heavy-looking, feathery, holey. Could we use words like this to describe these sculptures? Do the sculptures remind you of anything? Is anything happening? How does the sculpture make you feel? Do you like or dislike the sculpture? Can you think why?

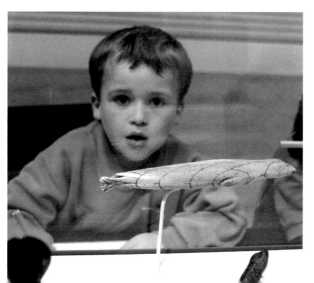

Experimenting with the wire and Plasticine

This project, photographs on page 56, involved constructing with wire, willow and Plasticine. The wire was soft and very easy to bend. It was pre-cut into a variety of different lengths, ranging from a few centimetres up to a metre. First, the children were given a little Plasticine and a length of wire to explore.

Play with the wire a little. What is it like? Play with the Plasticine. What is that like? Explore the willow sticks. Tell me some of the differences between the wire, Plasticine and willow.

Can you make three pieces of wire stand up together? Try out a number of different ideas.

Now, can you practise bending the wire to make some shapes?

You can make simple shapes like squares and circles but you can also make other shapes. Make at least four different shapes. Try to find ways of joining the shapes together to make them stand up.

Talking about the experiments

Ask the children about what they found easy and difficult to do. They will inevitably have encountered problems to do with balance and stability. This is a good time to introduce them to these concepts.

Above: exploring decorative and domestic objects from different parts of the world

Left: in the centre of the photo is an ivory seal from Alaska, made over 1000 years ago, from the Robert and Lisa Sainsbury Collection at the University of East Anglia

Session 6

Making a construction

Now you can make a sculpture of your own. Work together in groups of two or three. You will have to help each other all the time. See which group can construct the biggest wire sculpture. It must be stable. It's no good if it keeps falling over. You can use any of the materials and there are materials for tying and fixing as well. Just experiment.

The children don't have to try and make anything they can recognise. In fact the most useful work will be abstract, as they gradually try to build up a large and more complex structure. As part of the project, we talked about images of sculptures by the British artist, Anthony Caro. By referencing abstraction and what it means, and by reinforcing the need to explore and experiment, children here were able to discover some of the qualities of constructed abstract sculpture including: strength, balance, pivot, support, structure and qualities of the materials.

Some children in our project chose to make sculptures that related to familiar things. One group chose to make a bridge, another a sculpture based on the visit to the art gallery.

Drawing the finished construction

The wire sculptures made excellent objects to draw. This would clearly link to work on line. (Look at pages 26–27 for other ideas about line.)

First of all, find the point of view from which you would like to draw your sculpture. Look around the sculpture first before deciding. Look carefully at all the different lines and shapes you can see. Here is a large sheet of paper and a selection of materials to draw with. Think big!

You will need: wire and willow sticks pre-cut into different lengths; Plasticine; string; other materials that could be used for fixing including paper clips; drawing materials and paper for drawing the constructions.

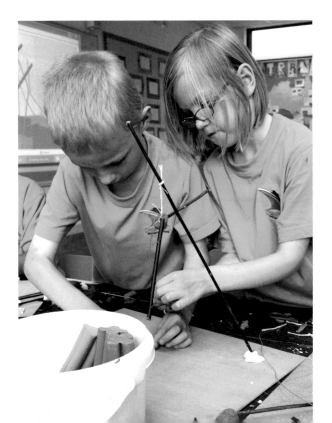

Above: a butterfly made from wire and willow

Right: exploring sculptural construction. This open-ended project really helped children explore their creativity. There are so many possibilities

Left: the class sculpture made as part of the visit to the Sainsbury Centre for Visual Art. Pupils worked with artist Doo Gurney. Each object in the willow net has a special significance, inspired by stories behind some of the ethnographic objects in the Centre's collection. The labels give museum-style information about each object

Below: detail from a willow sculpture made in the Sainsbury Centre workshop. You can easily make something like this in school. Children will delight in combining objects to make a shared collection

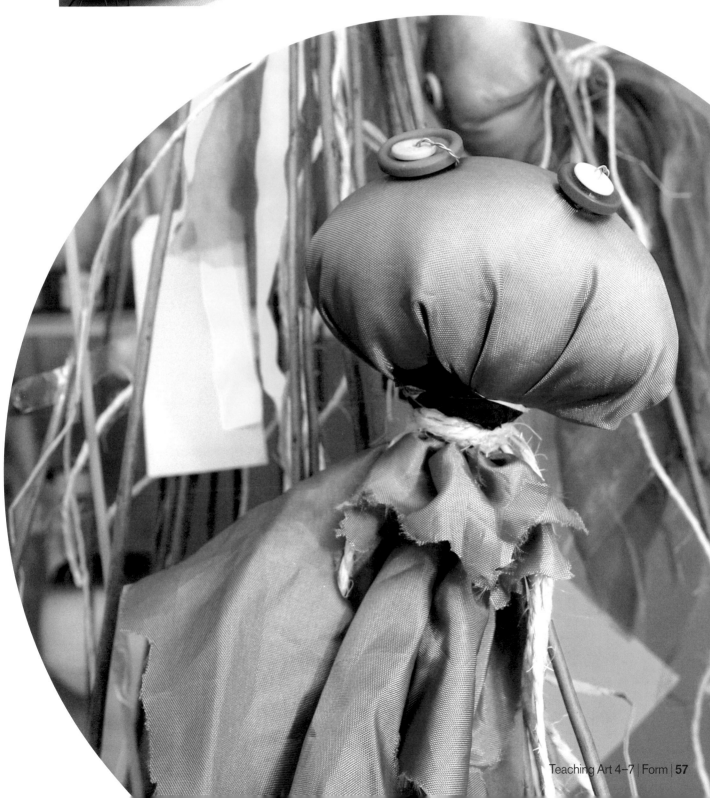

"He's getting bigger…now he's the same size as she is, now he's a giant! He hasn't really grown bigger… he just looks bigger because he is closer."

Looking at space inside

Session 1

Drawing objects one at a time as they appear on a magic table

The children should already know about drawing the outline shapes of objects. Try some of the shape exercises on pages 16–17 as a warm-up and reminder. In this session, you will be building the children's vocabulary about space with words and phrases like 'next to', 'on top of', 'behind', 'in front of', 'between' and 'underneath'. If you want to explore concepts such as 'in front of', children will need to become familiar with the idea that shapes can overlap in their drawings. There will be lots to talk about in these drawings. What children draw will depend on where they are sitting and their point of view.

Here is a magic table! Things are going to appear, one at a time. I wonder what the first thing will be? Here it is: a saucepan. Look where it's going to go. I am putting it in the middle of the table. Put your drawing in the middle of your paper. Think about the shape. Draw the outline.

Now here is a container for salt. Where is it going to go? Next to the saucepan? Beside the saucepan? On which side of the saucepan is the salt? Is it touching the saucepan or is there some space between them? Look carefully at where it is going on the table. Where do you think you should draw the salt container on your paper?

Here is a set of kitchen scales. I am going to place it behind the saucepan. Look carefully. Does the saucepan hide part of the kitchen scales? Can you draw the scales so that some of them are hidden behind the saucepan? How are you going to draw the scales on your paper? You don't have to draw the parts you can't see, the parts that are hiding.

You will need: at least A3 paper – ask the children to think big; drawing boards are helpful, as they create extra space for the children to work; any drawing medium that makes a strong clear line, for example, black wax crayons, black felt-tip pens and soft pencils.

Right: drawing objects as they appear, one at a time, on a table. This photograph shows work that was also part of an exploration of weighing and measuring

Below: we talked about space in the classroom, before drawing

Session 2

Drawing space in the classroom

We are sitting at one end of the classroom. Can you tell me what things are the furthest away from us? What is close to us? What about some of the things in between? What is in front of the big table? What is behind? What is between the big table and the door?

The children could talk about the way one object overlaps, or partially covers another. For example, the chairs overlap the cupboard door, or in other words, the chairs are **in front of** the door. If you would like a warm-up for this activity, ask the children first of all to experiment by drawing two-dimensional shapes that overlap.

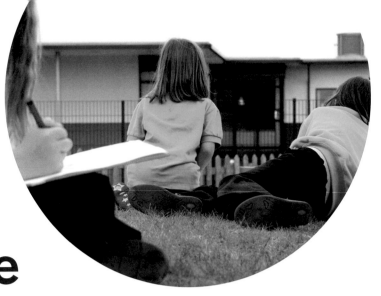

Looking at space outside

Session 3

Talking about objects near to and far away

Find two children in the class who are the same height. Then take the class outside.

Send one of the two children about 40 metres away, or to the back of the playground.

Ask the second child to stand 20 metres away, between the first child and the class.

We are all standing and looking at the two children. Is there a difference between them? Remember that inside the classroom, we found that they were the same height.

Ask the child who is furthest away to walk slowly towards the class. They should stop when they reach the second child. Now ask the first child to walk forward until they are really close to the group.

What is happening? Are they still the same height? What happened as he walked towards us? He seemed to get taller as he walked towards us. Let's try this again. Look how small he looks at the back of the playground. What other things look smaller when they are further away?

You have been showing children the effects of perspective. Other good examples to look at are houses down the street, railings, street lights, trees, long fences and cars.

Drawing things near to and far away

We have found out that things look smaller in the distance and bigger when they are close to us. Look carefully and see if you can show this in your drawing.

Work outside or find a view from a window. If you are working outside the classroom, the children will need drawing boards to rest on. If it is windy you will need masking tape for the corners. Use A3 paper and soft pencils, black wax crayons, handwriting pens, etc.

You are going to ask the children to take an imaginary walk through the real space that they can see. You will need to be able to see a reasonable distance, either standing outside or looking from a window.

What can you see that is the furthest away from us? Now imagine that you can stand there. You have magic powers and can walk right through or over everything in a straight line all the way back to where everyone is waiting. What do you pass first of all on your walk, what do you pass next, and after that? Let's make a list starting with the far away things and gradually adding the others as we pass them.

Now you can draw. First of all draw the things that are furthest away. Then draw what you would pass next on your magic walk, then the next things, until you are close.

The children might draw one thing on top of another, building up the drawing with lots of overlapping shapes, lines and marks. If they are used to drawing only what they can see, they might be able to show that one thing hides part of another. In other words, if all of an object isn't visible, the children need only draw what they can see.

Above: looking at space outside

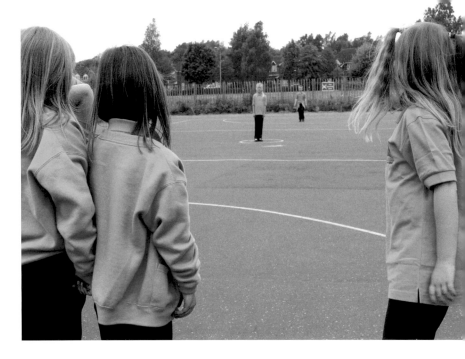

Right: what happens as he walks towards us?

Below: can you see that the fence looks smaller the further it is away from us?

Talk about these drawings in the same way that you talked about the objects in the classroom in the previous activity on page 59.

Another idea is to give the children strips of paper. Perhaps they could draw all the things they can see in the distance on one strip, and those things in the foreground on another? You could even have a strip for the middle-ground! Ask the children to combine the strips in one new, larger drawing.

You will need: sketchbooks or A3 paper and drawing boards; drawing media (the children could choose their own – some will prefer charcoal, others handwriting pens, others soft pencils, etc. Choice helps children explore and form an individual drawing style).

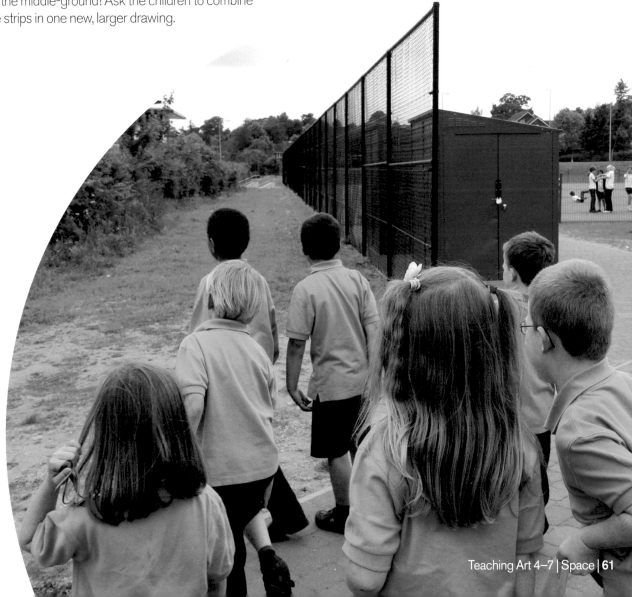

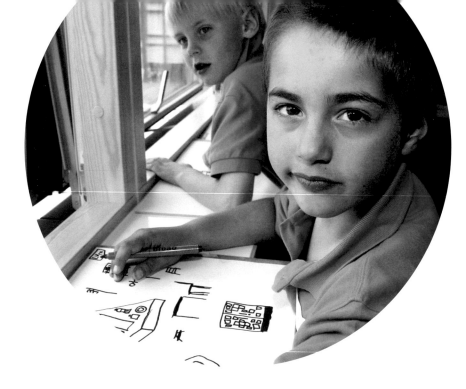

Session 4

Talking about space in landscape painting

Here is a painting, a landscape. What can you see? We can keep a note of what you say. Which part of the painting is furthest away? Which part is closest to us? Now we can pretend to walk through the painting. We will walk through the painting starting at the front and moving into the distance. What would you pass on the way? You have magic powers and can pass through or over everything. We can make a list of everything that you pass. Describe everything you can see in the foreground – all those things that seem to be closest to us. Now describe everything you can see in the background, in the distance.

You could go on to ask the children what they can see in the middle-ground. Use the new words here, 'foreground' and 'background'. Add the word 'middle-ground' if you think it is appropriate. This could equally relate to talking about a townscape, an industrial landscape painting or drawing. Paintings of interiors often show a complicated space. In the case of an interior, perhaps the children could imagine themselves as mice or ants that are walking through the space of the painting.

You will need: drawing materials (see page 16); examples of landscapes.

Imaginative drawing with a focus on space

Ask children to experiment by making an imaginative drawing that shows foreground, middle-ground and background. One tactic is to suggest that as they draw, they imagine that they are making their own journey from the background to the foreground, adding additional elements to the drawing as they go. Overlapping shapes might be an important feature of these drawings. This will be even clearer for children if they use collage. The resulting work could be a mixture of drawing and collage, with a developed sense of foreground, middle-ground and background.

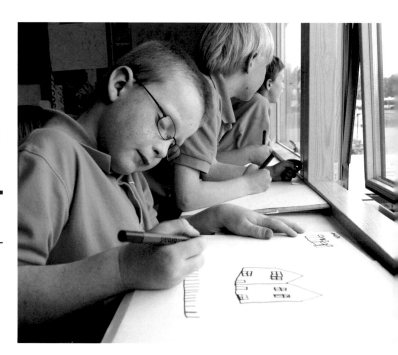

Top: collecting the shapes of things near to and far away
Above: looking for foreground, middle-ground and background
Opposite: talking about space. Which part of the painting is furthest away?

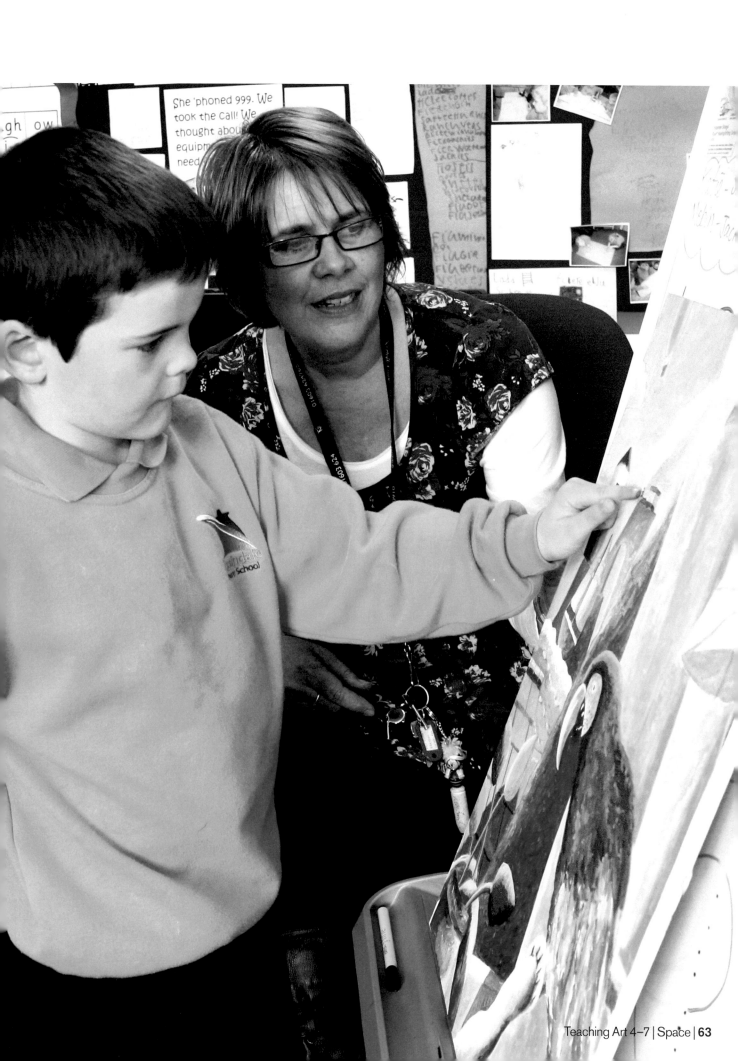

7

"At the back of the cupboard, in a cave, where worms live, behind the book box…it's scary…No, I like it when it's dark…let's stop the sun getting in and make everything dark!"

Light and dark

Session 1

Talking about light and dark

There are some dark places in this classroom. Where are the darkest places? Look around. Why are these places dark? How could we make them lighter? Where are the lightest places in the room? Where can you see shadows? Look for shadows. How can we make a shadow?

Take children into a room that you can black out. Talk about what it is like in the room and then let some light in. They will be learning that they need light to see. If you cannot find a dark room, then simply close the blinds or curtains in the classroom.

Ask children to experiment by making shadows. Link the discussion of light and dark with memories and feelings, for example:

Have any of you been anywhere where it is really dark? Let's make a list of dark places. What are they like? How did you feel?

Right: we found a dark place

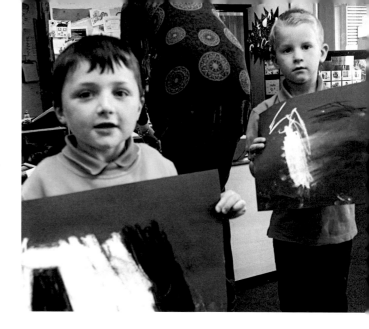

Right: making light and dark patches
Below: experimenting with charcoal and chalk

Experimenting with light and dark

Here is some charcoal and some chalk. Which one would you use to make a dark patch? Which one would you use to make a light patch? You can experiment and make some dark and light patches on your paper. What happens when you mix the charcoal and chalk together?

Ask children to make patches of light and dark. Show them a patch of charcoal and say, "No pictures, just patches". You will need to reinforce this from time to time while they are working.

Talk about all the different greys the children find. Ask them to talk about the different shades of grey and how they made them. It is important to let them talk about their experiments. Drawing boards will be very useful here. They will help you find extra space in the classroom, so that all children can experiment at once.

You will need: chalk; charcoal; firm-hold hairspray; dark paper (at least A3).

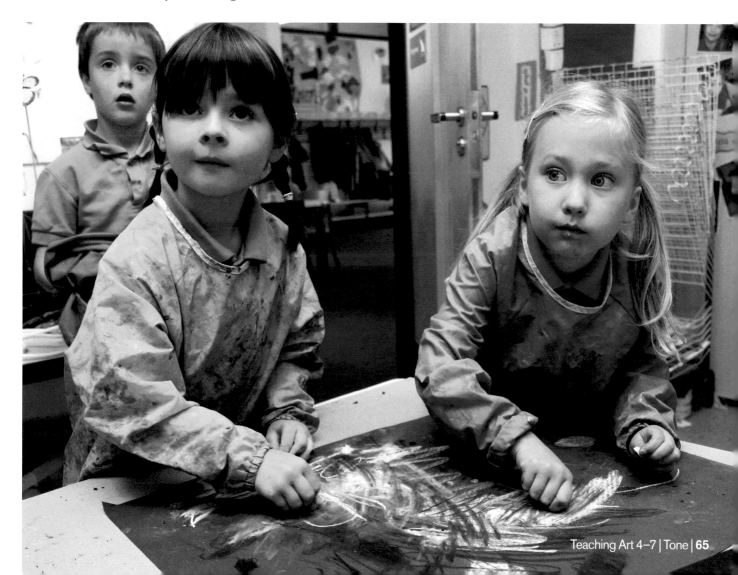

Looking for shadows and discovering tone

Session 2

Making a tonal scale

You could introduce the word 'tone' here. Use terms like 'the darkest tone', or 'the lightest tone'. A good way to help Reception children understand this idea quickly is to talk about hair tones.

Who has the darkest hair in the class? Has anybody got really black hair? Let's choose the person with the darkest hair. Who has got the lightest hair in the class? Is there anyone who is really blonde? Let's choose the person with the lightest hair.

Let's choose two more children, one who has lightish hair and another one who has darkish hair. I'll help you choose.

The class can now decide in which order the four children should stand to show a progression from dark to light tones.

Now we could use charcoal and chalk to make a tonal scale. Start on one side of the paper with a dark patch. Put a very light patch on the other side and make patches of grey tones going from dark to light.

Challenge the children by asking them to increase the number of patches in their tonal scale. If you are working with older children, you could try these light and dark experiments with a range of different drawing media. The children could try soft pencils, black wax crayons, etc. If the children can mix colours, they can make tonal experiments and scales with black and white paint, or different colours. See pages 41–43 for advice about colour mixing.

You will need: buff or dark sugar paper; charcoal and chalk; drawing boards; firm-hold hairspray to fix the experiments; a camera to record the tonal scale of hair colour.

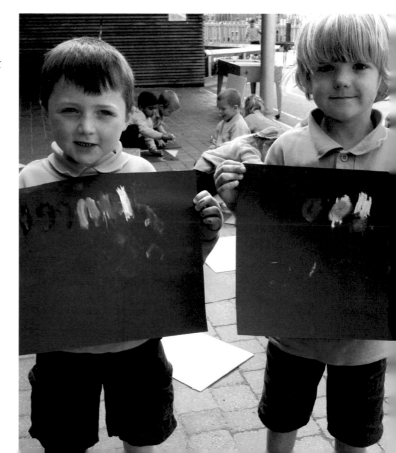

Above: who has the lightest hair?

Right: making a tonal scale from dark to light

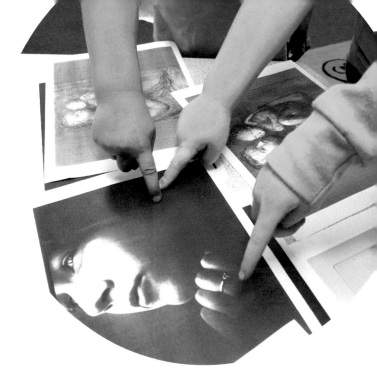

Session 3

Talking about light and dark in a drawing or painting

Find a reproduction of a drawing or painting where the artist has clearly used shadows and a variety of tones. Start by asking the children, "What can you see?" Encourage them to state the obvious!

I am going to make a list of all the things that you can see in this painting. Let's not leave anything out. Now, let's look at differences in tone. Where are the darkest parts? Where are the lightest parts? How did the artist make those areas so dark? How were the lightest tones made? Let's look for shadows.

You can talk about the drawings and paintings the children make in this way too. Try asking questions like:

What is happening in this painting? Does the painting remind you of anything? How do you feel when you look at this painting? Why? How are the people in the painting feeling? What are they like? What is it you like about this painting? Why? What is it you dislike about this painting? Why? Maybe some of you like this painting more than others?

Drawing tonally with light and dark

You can use some very simple white forms: a cylinder made from a roll of white paper; a sphere (use a white ball); a box painted white; a large paper cone. Put them on some white paper and use a lamp or spotlight to make shadows. Have the children experimented making simple forms in clay? Look back at page 50 for ideas.

What's happening here? Let's talk about the shadows. Look very carefully. Can you point to the darkest shadows of all? Who can show me the lightest parts? Make a drawing with chalk showing the lightest parts of the forms first. Then add the darkest parts with charcoal. You could try mixing charcoal and chalk for some of the other shadows.

Try shining the light from the other side and asking the children to make a second drawing.

Let's talk about the drawings. What did you find easy? What was difficult? Look at all the drawings. Can you choose one that you like? Can you choose one that you think works well?

Have an informal exhibition by laying all the work out in the corridor, or on the floor and table tops in the classroom.

You will need: charcoal and chalk; buff or dark sugar paper at least A3 size; firm-hold hairspray to fix the drawings.

Above: talking about light and dark in drawings, paintings and photographs

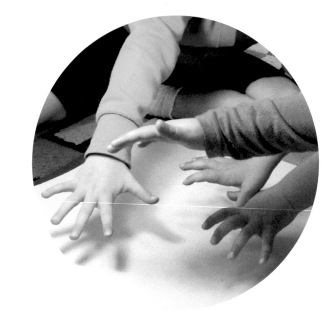

Tonal drawing

Session 4

Recording shadows

When it's sunny, our bodies make good shadows on the ground. How could we record these?

You could use a camera, or the children could draw around the shadows on large pieces of paper.

Ask the children to record the shadows they make when they are doing different things, for example: sitting, standing, reaching, running, standing on one leg, making a star shape. Make a link with the body shapes project on page 19. You could record the shadows that other things make, such as a chair or a toy.

Exploring light sources

Let's make a list of all the things you can think of that give off light. Here are some things that I have collected to show you: a torch, a candle, an oil lamp, an electric light. What is the light like that comes from the torch? What kind of light comes from the candle? I am going to make a list of all the words we are using.

Let's look at the different shadows that we can make. Who can pretend to be a torch? Who can pretend to be a candle? Now you can make some drawings of the different objects that give off light.

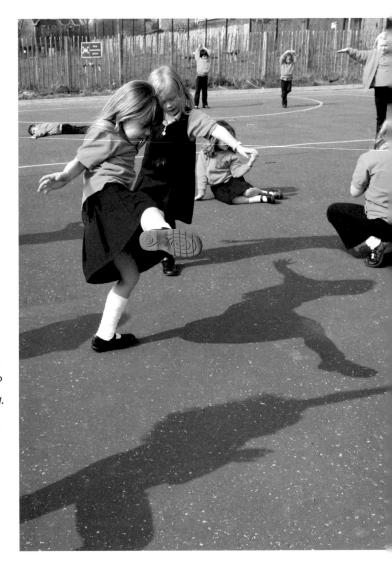

Above and right: making shadows

Session 5

Drawing a portrait looking for tone

First, ask children to make experiments with light and dark as on page 67. They could use different drawing media to explore light and dark and afterwards make a choice about what they would like to draw with. Talk about the experiments.

In this example I will assume that the children are going to draw each other. But the project would work well for any subject. Ask the children to find partners.

Look at your partner's head. Where can you see the darkest parts of the head? Where can you see the lightest parts? Where can you see shadows? We have been experimenting with different drawing materials making light, dark and grey patches.

When you draw, look for the dark and light areas and look for the shadows. Draw carefully and put in whatever you can see. Don't draw the outline first. Pick a spot in the middle somewhere, and work towards the outside of the head. This means that you will probably start with the nose or the eyes or the mouth. Keep going and don't worry about mistakes. When you have finished we can talk about the drawing.

A useful tip for children is that the eyes are halfway between the top of the head and the chin. You can adapt this project to draw buildings, landscapes, a cityscape, or a still life of objects connected with a topic. (Also see pages 20, 22)

You will need: drawing boards and masking tape or clips (if you are using charcoal, children will need large sheets of paper – try at least A3. Choose paper that is appropriate, for example, buff sugar paper for charcoal and chalk); a variety of drawing media from which children can choose.

Session 6

Making imaginative drawings using light and dark tones

There are many novels or stories that have passages concerned with the effects of light or of darkness. For example, *Who's Afraid of the Dark?* by Crosby Bonsall or *The BFG*, by Roald Dahl.

Listen to this part of the story. Close your eyes. Use your imagination and think about a dark place of your own. Is it a cave or is it night time? Is it in the attic or in a cellar? Where else could you be? What else is there? Make a drawing of the darkness.

Add in anything you like that will show us what is there.

If the children have not explored tone for a while, repeat some of the sessions earlier in this chapter to warm them up. Extend this project to encompass dark and light colours.

You will need: buff, grey or black sugar paper; drawing media to show different tones clearly – for example, charcoal and chalk, black and white pastels; firm-hold hairspray; children could also work in black and paint.

Top left: taking it in turns to be the artist and the model

Top right: imaginative drawing inspired by light and dark

8

Texture

"Sponge...crumpet...it's softer than the other one... looks like a towel, it has little bits of cotton that stick up to dry you...looks like the scales on a snake's skin...like a piece of toast, yes, burnt toast! Looks like the bark of a tree where a woodpecker has been pecking...looks like a beard a bit."

Exploring texture

Session 1

Talking about texture

After making a collection of surfaces (such as bricks, leaves, feathers, stone, moss, and tree bark), ask children to feel the materials and talk about what they discover.

Here are some things we have collected. They all feel different from one another. They all have different textures. If you could touch this one, what do you think it would it feel like? Now touch it with your hands. Tell me what the texture really feels like. I am going to make a list of all the words you have used to describe the textures.

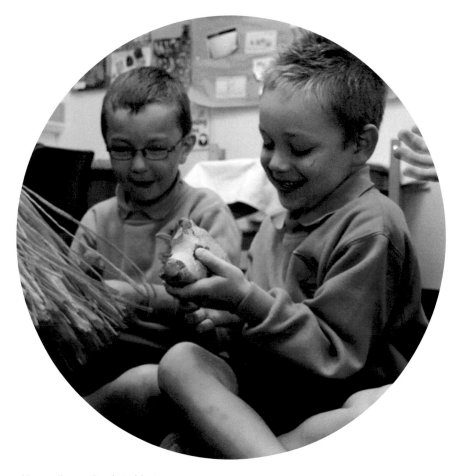

Above: discovering that objects have many different kinds of texture

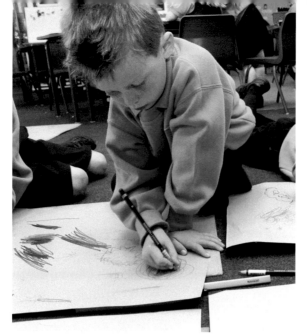
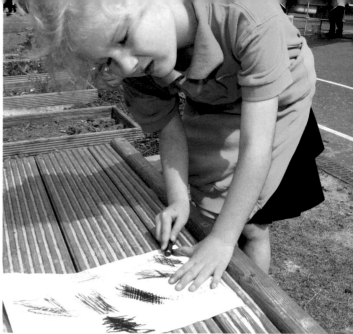

Session 2

Experimenting with marks to make textures

The children will say that the textures feel rough or smooth or feathery; some are soft, others are spiky etc. They are now going to experiment. Can they draw marks that correspond with the textures they have discovered? They will not be drawing pictures. Start off by trying this out with the whole class or group so that every one can see the idea.

Let's begin by using a black wax crayon. I'm going to make a mark that I think looks rough. Could somebody come up here and make a mark that looks rough? Could somebody come up here and make another rough-looking mark? Does that look really rough? Who can make an even rougher-looking mark? We could try making a soft mark.

Now you can try and make marks of your own. How about marks that are very feathery? How did you make that mark? Now we could try making marks for a bumpy texture. Could any of you think of a new texture to try? Remember our list. Just experiment, you don't need to draw a picture.

After talking about the materials and textures, try hiding the objects away while the children are drawing. You could also use feely boxes. Encourage children to talk about the textures they have made with the drawing materials.

You will need: strips of paper, if you want the children to store the marks one after another, or an A2 sheet of paper divided into two; a variety of drawing media such as charcoal, wax crayons, felt-tip pens and soft pencils.

Hunting and collecting more textures

Hunt around the playground and find as many different textures as you can.

Do you remember the different marks you made to go with the textures you found before? Can you draw these new textures? Don't draw the things, just draw the textures. You don't need to draw a picture, just make some marks to go with the texture. Now we can make a collection of things that have different textures and bring them back to the classroom.

Teachers and children can also use cameras to collect textures of different surfaces. You could look for the textures inside. Children can make rubbings. Visit the beach, some woodland, a builder's yard. This project links well to an exploration of materials in the natural and made environment. The experiments, drawings, photographs, natural and made materials make a good display. It is important to talk about the textures the children have drawn and collected.

You will need: soft pencils for drawing; wax crayons and graphite sticks make good rubbings; A4 paper and clipboards or sketchbooks; cameras.

Top left: experimenting with different marks to make textures
Top right: collecting textures outside

Textures with Plasticine and clay

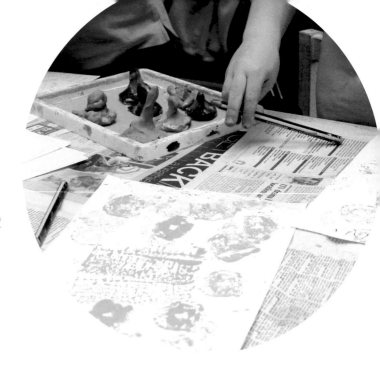

Session 3

Printing textures with Plasticine

Take a lump of old Plasticine and flatten one side. Demonstrate how you can press the flat side of the Plasticine onto a textured surface. Roll out some printing ink onto a plastic tray. Show the children how they can use the Plasticine like a stamp. They will be making prints using imprints taken from the surfaces of different materials.

What other textures could we find and print in this way? A good place to look is the playground. See what you can find. Choose one texture very carefully. Press the flat side of your Plasticine into the texture and bring it back to the classroom. Now you can make a print. Start at the top and work down to cover all of the paper with the texture prints. Don't leave any big gaps.

Why not pin the prints up immediately in a block, to make a display of work in progress and to let the prints dry? It will then be easy to talk about the printed textures. You can wash nearly all the ink off the Plasticine which can then be reused for more printing, when it is dry.

You will need: old Plasticine; flat plastic trays to roll out the ink; water-based printing ink; rollers to spread the ink in the trays; slightly damp rags or sponges for sticky hands; any paper.

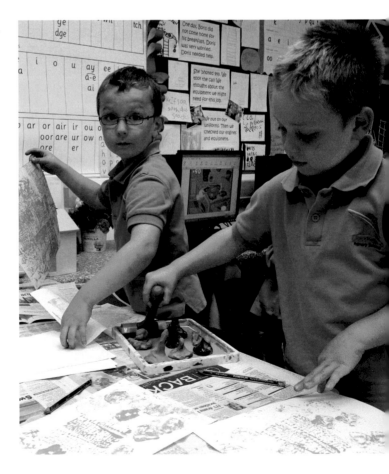

Above and right: printing with Plasticine

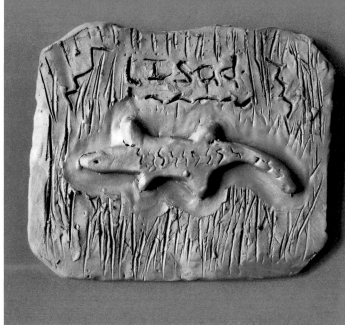

Session 4

Exploring textures in clay

You will need to make some clay slabs. Place the clay on a board between two lengths of wood that have the same thickness. Roll the clay flat with a rolling pin. You will have a smooth slab of even thickness. Clay can be difficult to roll out and the youngest children will need adult help, but can the children make their own slabs?

Cut the slabs into small squares or rectangles; 10 cm square should be more than enough. If you make the slabs in advance, cover them with cling film to keep them moist.

How could you make a texture in this clay slab? What could you use? Your finger? A clay tool? A lollypop stick? Has anyone got another idea? Could somebody show us how to make a texture that looks really rough? Could somebody else make a texture that looks bumpy? Could you each experiment and make a texture in your own clay slab?

The children could draw a line in the middle of the clay slab so that they have two areas in which to make textures. Or, why not divide a larger slab into four? Get children to talk about their clay slabs. Compare the slabs to the textured materials they have collected.

Animals in clay

Make some more clay slabs. Before starting to work with the clay, ask the children to look through books to find simple animal shapes. They can collect these shapes by drawing. Their animals will look better if they have done work on shape first. See pages 16–22. Ask the children to imagine they could touch the animals. Talk about the textures of animal skins, coats and scales.

Here are two new clay slabs. Draw the shape of your animal into the clay on the first slab with a blunt pencil. Make your shape as large as you can. You can cut the shape of an animal out of this slab with one of the clay tools. Does anyone have ideas about how to cut the clay? You might need some practice! When you have cut your animal shape out of the clay, you can use slip to glue it onto the other slab. Then you can begin to add texture to your animal. (See page 51 for how to use slip.)

Children can work individually, although it is often difficult for young children to cut the clay shape out of the slab. Many manage well, but some will need help. Children will find it easier to add the animal texture after the animal shape is stuck onto the slab. They could also go on to make ceramic tiles. Why not roll out a large slab of clay, say 80 cm square? A small group could add animal shapes and it would make an impressive plaque, or low-relief sculpture.

You will need: all the equipment for using clay; see page 51.

Top left: making shark shapes
Top right: this lizard lives in the grass and has rough skin

Drawing texture

Session 5

Drawing objects one at a time, focusing on textures

You will need a number of objects with interesting and different textures, for example, a cauliflower head, a ball of moss, a large spiky shell, a pineapple, a coconut, a soft toy. This project will work best if the children have an awareness of shape. Look at pages 16 and 21 for ideas about how to help children draw shapes. The children will be drawing each object in turn, to help them focus on textures.

Ask the children to draw the shape of the first object they have chosen. Ask them to fill in the textures they can see with marks. Encourage them to go slowly and see how close their marks are to the textures of the object. When they have finished, they can choose another object. An alternative approach is to start in the middle of an object and work towards the outside, building up the drawing with marks. They can add in outlines when they come to them.

Feel your object carefully. Put it down and look at it. Can you see the way it feels?

How do you know something is rough without touching it with your hands? Look at each little crevice, bump, furry or soft bit. This is like touching with your eyes!

Try making these texture drawings on large pieces of paper. You can use up to A1 size if you have the space. Young children will make large drawings if you ask them to think big. Marker pens are great for very large drawings. Ask the children to cover all the objects they have drawn with texture marks.

You will need: paper, small or large; charcoal, soft pencils, black wax crayons, marker pens and felt-tip pens; drawing boards will be useful for large work.

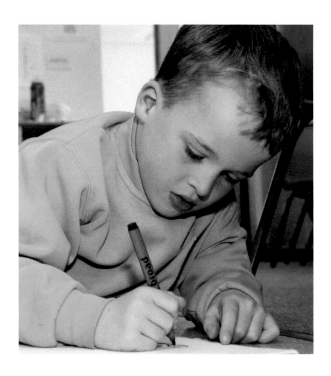

Above: textures of a cauliflower

Right: exploring textures helps children focus when they draw

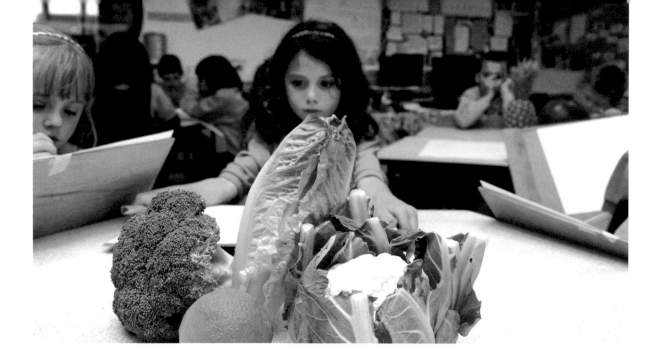

Talking about textures in paintings, drawings and sculptures

We have been exploring textures. What about the different textures in this sculpture? How has this artist made different textures? Can you say what the marks are like? Who can point out texture in the sculpture? To help we can look at our list of words, or I can remind you of what we talked about when we were looking at textures. Have you made any marks in your own drawings that look like the marks the artist made?

You can often see how artists have painted, drawn or made textures. Talk about good examples with the children and ask them to make comparisons with textures in their own work.

Drawing a group of objects

This session is intended to help children make still life drawings with texture as a focus. Make a collection of natural objects that have different and interesting textures. Talk about the textures in the collection of natural objects. Then ask children to experiment and talk about making marks for the textures of the objects. If you give them an opportunity to 'warm up' by making texture marks, and then talk about the what they have done and the textures they see in the objects, the quality of the final still life drawing will be enhanced. See pages 70–71. Children may complain about 'making mistakes'. One approach is to convince them to keep going, as a mistake made at the beginning of a drawing often seems much less important by the end.

You will need: paper, small or large; charcoal, soft pencils, black wax crayons, marker pens and felt-tip pens; drawing boards will be useful for large work; a collection of objects with interesting textures.

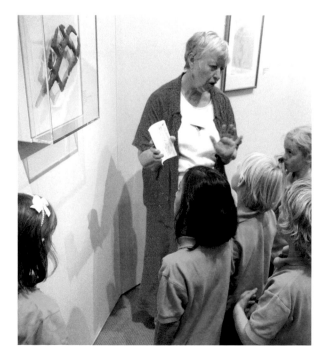

Above: these children are able to focus on the texture of fruit and vegetables because they have been exploring texture first

Left: talking about how an object might feel if you could touch it – at the Sainsbury Collection at the University of East Anglia

Equipment

This list provides a basis for ordering the materials and equipment needed for projects described in the text. Although almost everything listed is mentioned in the book, neither text nor list is intended to be comprehensive, but provides a starting point for ordering materials for your class or school. All materials and equipment should be used safely. What is your school policy on health and safety? Especially if you or the children are working with materials and equipment for the first time, identify any health and safety issues and build appropriate advice or warnings into your teaching.

Drawing

Paper: use white cartridge paper as funds allow. You will need different sizes: you will use far more of A4 (210 mm × 297 mm, which is computer printer size or similar) and A3 (double the printer paper size) than other sizes. You will need larger sizes or drawing paper on a roll for big drawings.

Newsprint or lining paper in sheets or from a roll

Sugar paper: buff, off-white, grey or black and coloured

Thin white card

Drawing materials: drawing pencils (4B are best); black handwriting pens (or any thin, black, felt-tip pens); black wax crayons (both thick and thin); black biros; washable marker pens; charcoal

Drawing materials for colour: coloured wax crayons; coloured pencils; coloured felt-tip pens; soft pastels; white and coloured chalk

Inexpensive hairspray or fixative (adult use only) for chalk, charcoal and pastel drawings

Sketchbooks: not essential for younger children but I recommend sketchbooks for 6 and 7 year olds if resources allow. Children can make their own books as part of a design and technology-focused project

Clipboards

Drawing boards: the most useful size is about 310 mm x 430 mm, slightly larger than A3; bulldog clips; masking tape, particularly if you are drawing outside and it is windy. Larger drawing boards to fit bigger sheets of sugar paper would offer flexible work spaces for bigger drawings.

An easel for large group drawings and demonstrations

Collage

Boards: with a line down the middle marking a clean and dirty side to help children organise their work area. I recommend cutting sheets of hardboard to fit two rectangular classroom tables. These provide excellent protection for the table tops underneath and are quick to prepare and put away.

Scissors

PVA glue; small pots for glue; glue spreaders

Old newspapers and magazines

Paper (see *Drawing* above)

Damp rags or sponges

Containers for paper shapes ready to collage

A range drawing media to use on top of the collage

Printing

Water-based printing inks; plastic trays to roll out ink; rollers

Smooth polystyrene tiles suitable for printing

Pencils, or something to make an impression on the tile

Paper (see *Drawing* above)

Damp rags or sponges

Old newspapers and magazines, preferably cut in half: each time children ink up tiles they will need a fresh sheet.

Protective covers for table tops (see *Collage* above)

Using clay

Clay: earthenware clay is rich red in colour, so use buff-colour clay if you want to paint the objects. It is advisable not to mix different kinds of clay

Clay boards

Clay tools or use lollypop sticks, old cutlery etc.

Polythene food bags to hold individual portions of clay

Damp rags and sponges; trays for sponges

Small pots for slip; brushes to apply slip

A system for storing the clay objects when dry

False glaze: mix equal quantities of PVA glue and water and paint on objects.

Painting

Ready-mix or powder paint: see page 43 for a range of colours to use

Pots for the powder colour and ready-mix paint: 6 small yoghurt/dessert pots in a plastic food container work well

Flat, mixing palettes: tops of large, plastic food containers can easily be used

Large containers for water: bigger, more stable containers that are shared are better than small individual water pots.

Brushes in different sizes

Thick and thin paper (see *Drawing* above)

Rags or sponges

Fabric design

Examples of patterned fabrics

White cotton or cotton-mix material

Fabric crayons or paint

An iron (adult use only)

Staple gun (adult use only)

Paper and drawing media for designing (see *Drawing* above)

Wooden boards for stretching out the fabric

Construction

Scrap cardboard

Soft and pliable wire

Wire cutters (adult use only)

Scrap pieces of wood

Assorted tools and materials for cutting and fixing (adult use only)

Willow sticks of different lengths

Plasticine

String; threads and wool; masking tape

Storing children's art

Clear plastic portfolio wallets: useful for storing children's 2D work. Make inexpensive wallets for each child to hold all but the largest work by stapling a sheet of strong polythene around three edges of a sheet of A2 card. You could also put in print outs of digital work and photographs of 3D work. These wallets can be taken home at the end of the school year or kept in school as a record of work in art.

Where to go next?

Here are some suggestions for places to look for new and interesting sources of materials, ideas and future projects. Also included are locations and activities for you to consider. There is a great deal out there for teachers to discover, but some of it requires a little ingenuity to unearth and use to its best potential.

Digital

Do you have access to digital cameras for the children to use?

What image presentation and manipulation software could children use? Can you use ICT to support art and design projects?

Do you use online sources of images of art – for example, major art gallery websites?

If you use a whiteboard to project images, can children see colours and details clearly, or do you need to improve black out?

Photocopiers and printers are excellent for reproducing and manipulating images. Are you able to access these?

Museums and galleries

Are you able to visit galleries and museums, and are you aware of any of their education services? You could visit places of worship, or take children to see public art, such as statues, monuments or memorials.

Do you have a collection of fine art posters?

How are images displayed in the classroom?

Art and design

What examples or art and design are easily accessible from school?

Have you considered making a collection of examples of design, remembering that most products we buy have been created by artists and designers?

Are there artists or designers who could be invited into school? There may be colleagues or parents who have specific skills they can share. Can you take advantage of this?

What professional development programs or courses about teaching art are available in your area?

Index

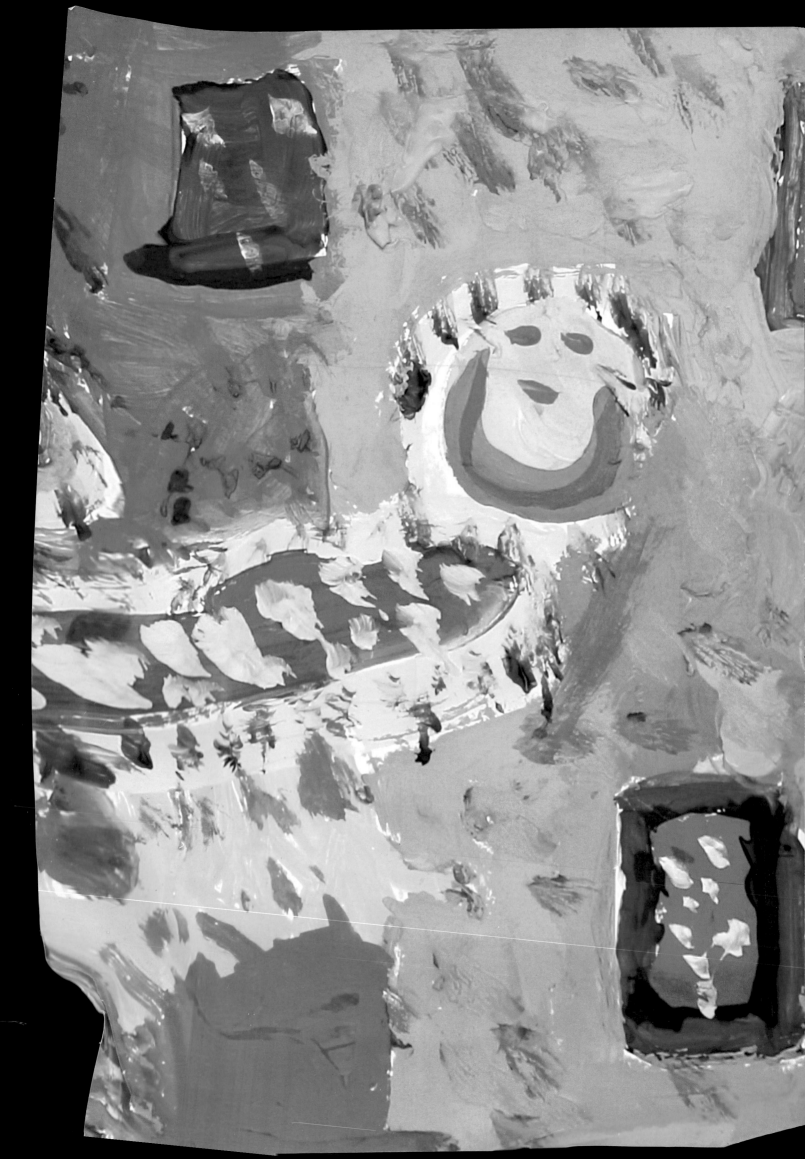